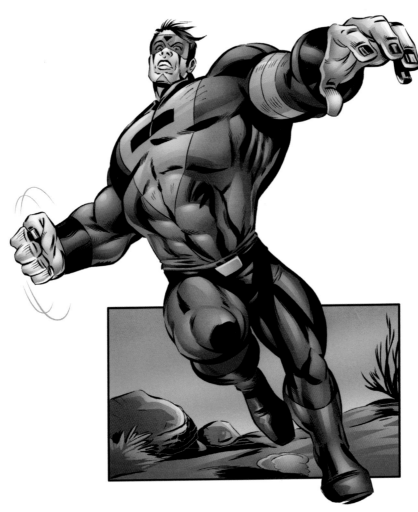

DRAWING SUPERHEROES
STEP BY STEP

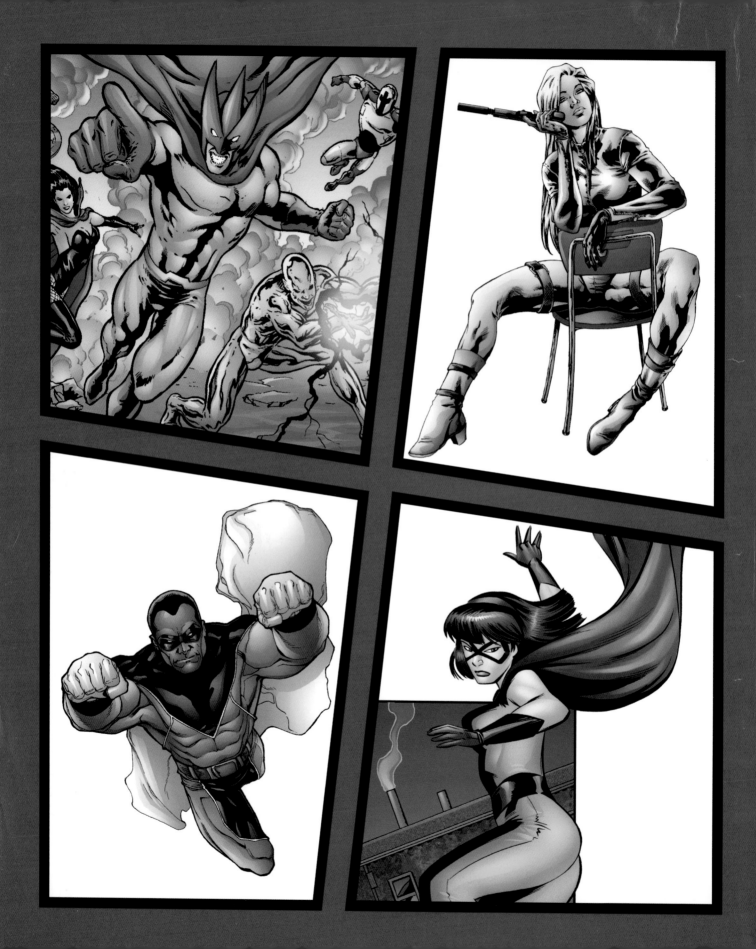

sixth&spring
books

DRAWING WITH Christopher Hart

DRAWING SUPERHEROES
STEP BY STEP

THE COMPLETE GUIDE FOR THE ASPIRING COMIC BOOK ARTIST

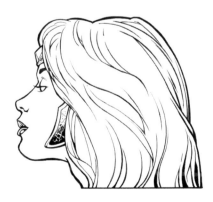

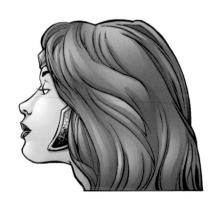

DRAWING WITH Christopher Hart

Editorial Director
JOAN KRELLENSTEIN

Assistant Editor
JACOB SIEFERT

Managing Editor
LAURA COOKE

Design
STUDIO2PT0, LLC

Art Director
DIANE LAMPHRON

Production
J. ARTHUR MEDIA

Vice President
TRISHA MALCOLM

President
ART JOINNIDES

Publisher
CAROLINE KILMER

Chairman
JAY STEIN

Production Manager
DAVID JOINNIDES

Contributing Artists: DARRYL BANKS, WILL CONRAD, ANDY KUHN
FABIO LAGUNA, LUIZ LIRA, PHIL MAY, GRANT MIEHM, FRANCISCO
OLIVEIRA DE AMORIM, CESAR RAZEK, KEVIN SHARPE

Library of Congress Cataloging-in-Publication Data
Drawing superheroes step-by-step : the complete guide for the aspiring comic book artist / Christopher Hart.
 pages cm
 ISBN 978-1-942021-60-5
1. ART/Techniques/Drawing. 2. ART/Techniques/Cartooning. 3. ART/Techniques/General.
 NC1764.8.H47 H37 2016
 743.8—dc23

2016004437

Manufactured in Canada

1 3 5 7 9 10 8 6 4 2

First Edition

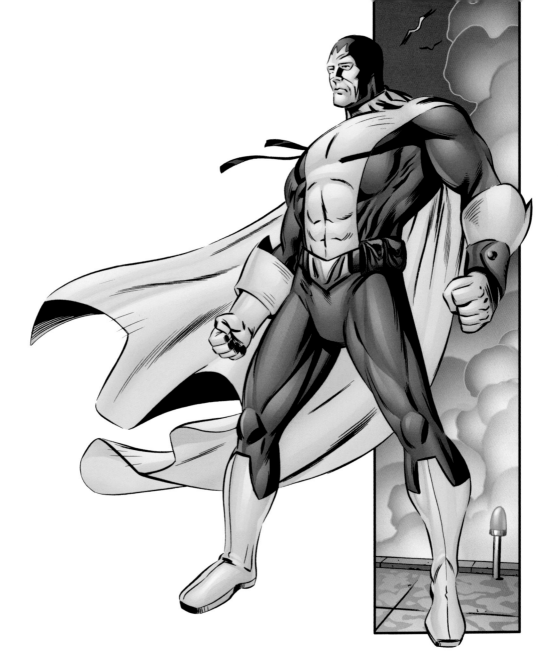

Dedicated to all the super-powered, aspiring artists who battle evil and messy pencil shavings!

www.christopherhartbooks.com
www.facebook.com/LEARN.TO.DRAW.CARTOONS
www.youtube.com/chrishartbooks

CONTENTS

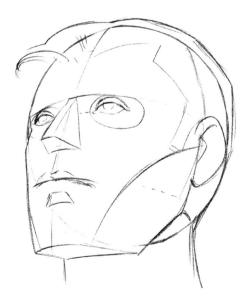

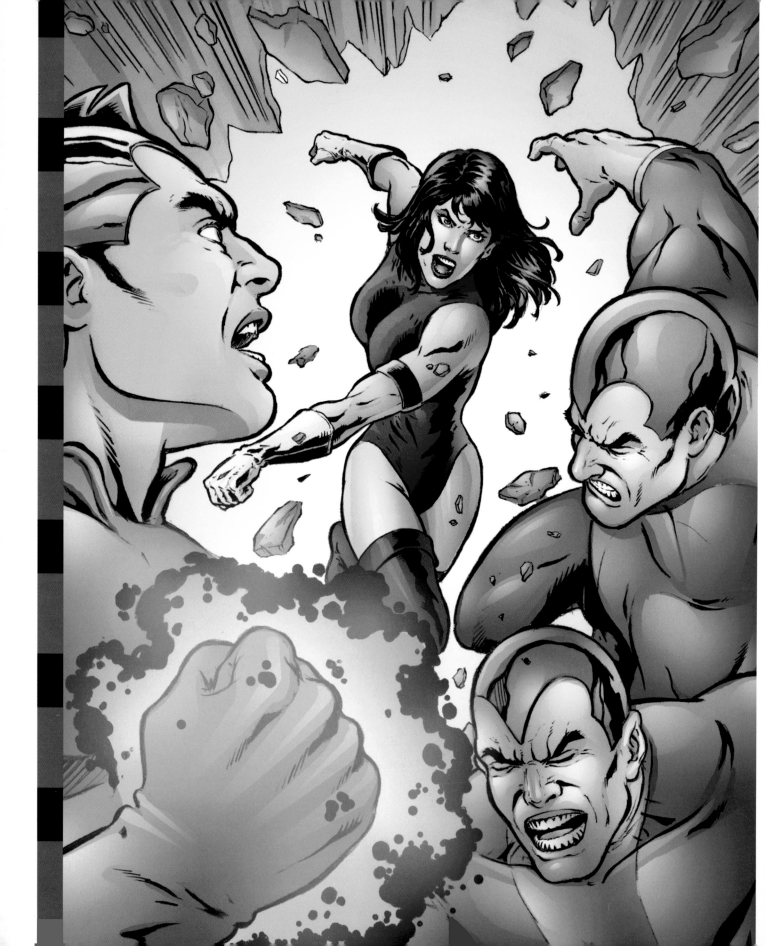

INTRODUCTION

SUPERHEROES ARE THE MOST POPULAR CHARACTERS IN COMICS. Their eye-catching costumes, superpowers, and towering physiques capture the imaginations of readers of all ages. Now there's a book devoted to how to draw all aspects of them. This book is for beginners as well as more experienced artists. These carefully crafted, step-by-step tutorials will help you to crush the competition. That's because there are a huge number of illustrated examples in this book. You won't have to read your way into drawing, you'll see exactly how to do it.

Other major character types are also featured, such as super-powered females and supervillains. In addition, we'll go beyond superheroes and learn how to draw the compelling supporting characters essential to any good action-adventure story, including news reporters, paparazzi, mutants, and more. We'll also cover exaggeration, expressions, costumes, using light and shadow to create intensity, drawing the splash page, and layout composition.

The power of the universe is in your hands.

Christopher Hart

YOUR HOW-TO-DRAW SHERPA

THE SUPERHERO HEAD

SUPERHEROES ARE LIKE ORDINARY PEOPLE but with more of everything. More virile, more rugged, and more dynamic.

Drawing superheroes isn't just a matter of sticking a mask on a face or a cape on a body. You've got to start with the right proportions in order to create that look of intensity for which superheroes are famous. We'll begin with the head and then reveal the secrets to creating charismatic crime fighters.

THE BASIC HERO

THE HEAD IS NOT BASED ON AN EGG SHAPE, primarily because of the wide chin of the superhero. The male head is more of a boxy-looking oval.

In realistic drawing, the eyes fall exactly halfway down the head. But for idealized comic characters, the eyes are placed slightly higher. Note, too, the narrowness of the eyes; this gives the character a severe look. Keep the length of the mouth short. Lastly, add a facial crease on each side of the mouth.

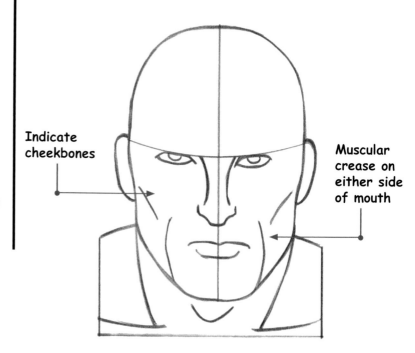

Indicate cheekbones

Muscular crease on either side of mouth

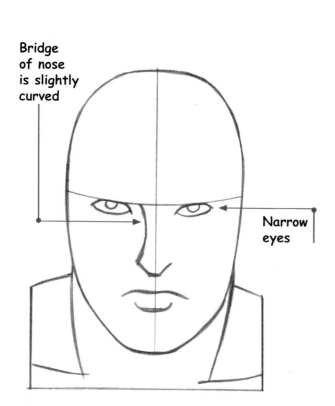

Bridge of nose is slightly curved

Narrow eyes

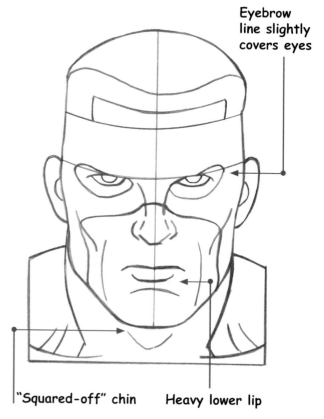

Eyebrow line slightly covers eyes

"Squared-off" chin

Heavy lower lip

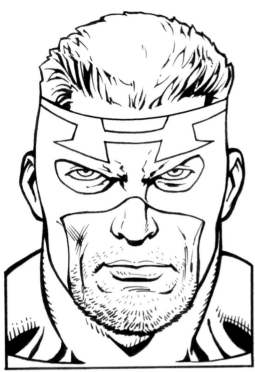

The black and white and color versions are where you add details such as the design on the mask, the hair, and stubble on the face.

LOOKS LIKE SOMEONE GOT UP ON THE WRONG SIDE OF THE BED.

PROFILE

In the profile view, you can really see how massive the jaw is. The base of the jaw, just under the ear, is actually a muscle known as the *masseter*. It gives him a masculine, rock-hard look. The chin is rounded and juts forward only about as far as the lips do. Notice, too, that the forehead slopes down to the bridge of the nose at an angle. Some beginners make the mistake of drawing the forehead as a vertical line, which makes the character look like a blockhead. A slightly sloping angle gives him a sleeker look.

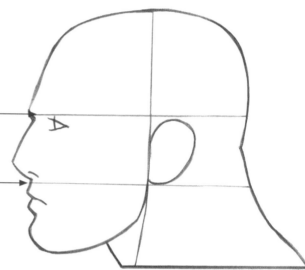

The bridge of the nose and top of the ear are on the same level.

The bottom of the nose and bottom of the ear are on the same level.

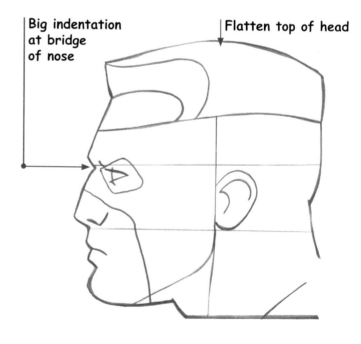

Big indentation at bridge of nose

Flatten top of head

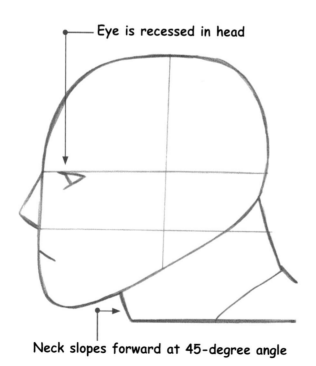

Eye is recessed in head

Neck slopes forward at 45-degree angle

14

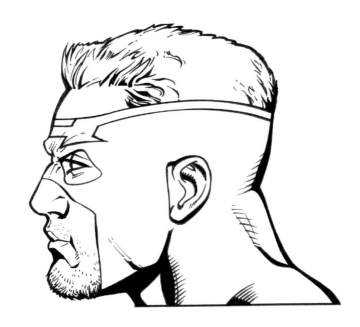

DRAWING THE MASK

You'll get better results if you draw the features before you add the face mask because you'll establish the underlying facial structure correctly.

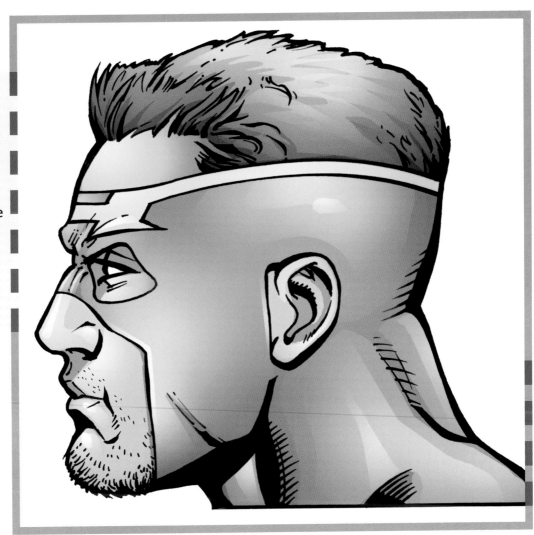

THE BASIC HEROINE

THE FEMALE HERO'S HEAD is the same as the guy's head, but more tapered. Her eyes are larger than male eyes, too. The eyebrows are higher and arching—a glamorous effect.

Super angular cheekbones? Only if she's a supervillain. Just lightly indicate the cheekbones or omit them entirely.

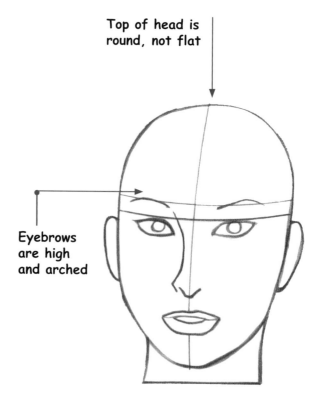

Top of head is round, not flat

Eyebrows are high and arched

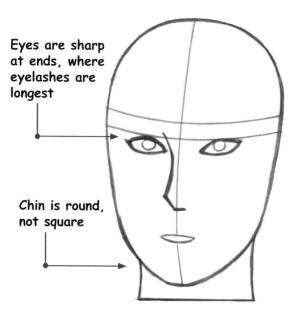

Eyes are sharp at ends, where eyelashes are longest

Chin is round, not square

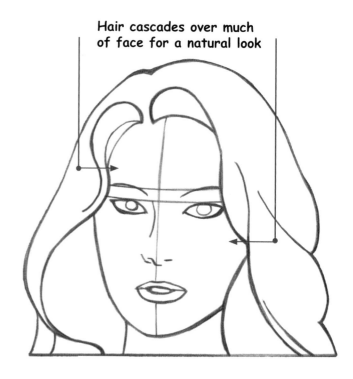

Hair cascades over much of face for a natural look

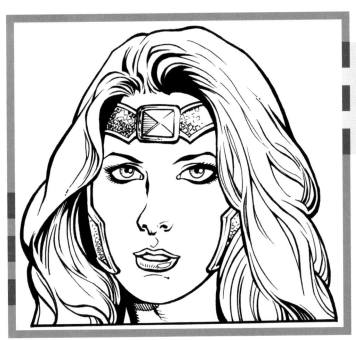

Draw casual-looking hair. If you draw every strand neatly in place, it will appear as if she got spray-painted.

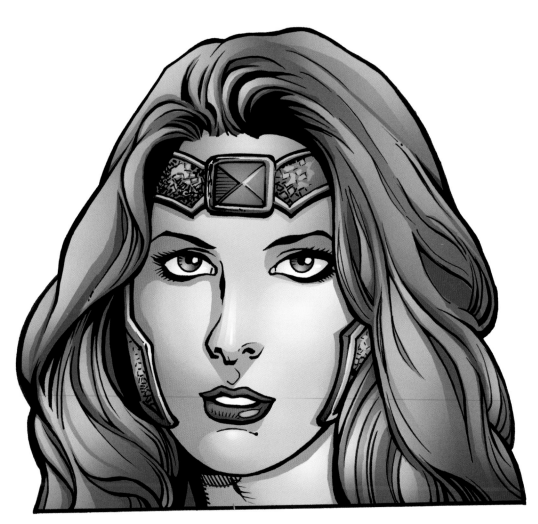

PROFILE

Unlike the man's chiseled profile, the female side view reveals a soft jaw line that connects to a flexible, long neck, which gives her an elegant quality. The upper eyelashes are the longest—sometimes even extending past the perimeter of the face. The lips are drawn oversized, and they protrude in profile.

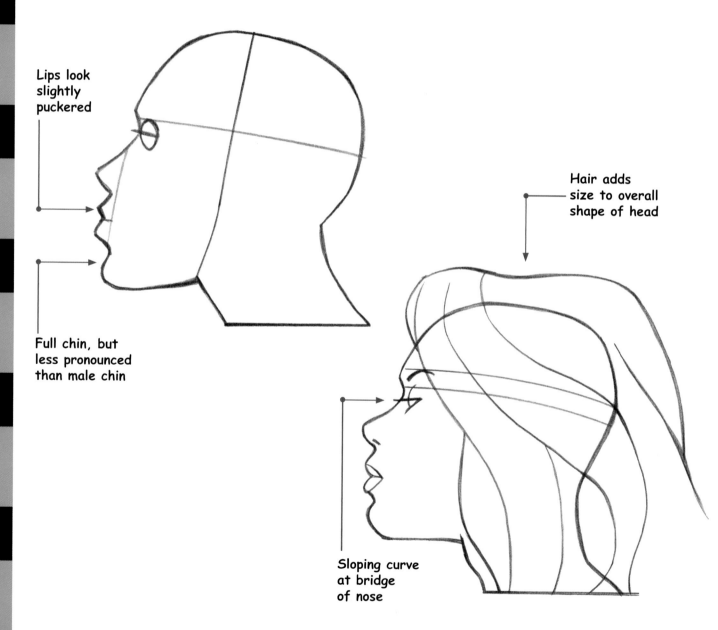

Lips look slightly puckered

Full chin, but less pronounced than male chin

Hair adds size to overall shape of head

Sloping curve at bridge of nose

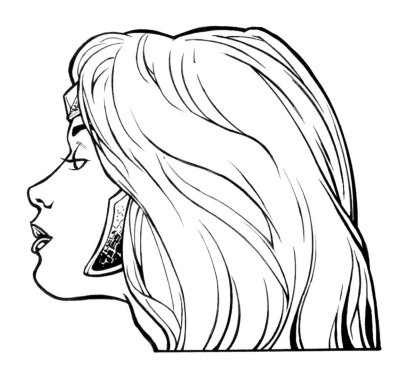

BEAUTY AND
POWER IS A
FORMIDABLE
COMBINATION.

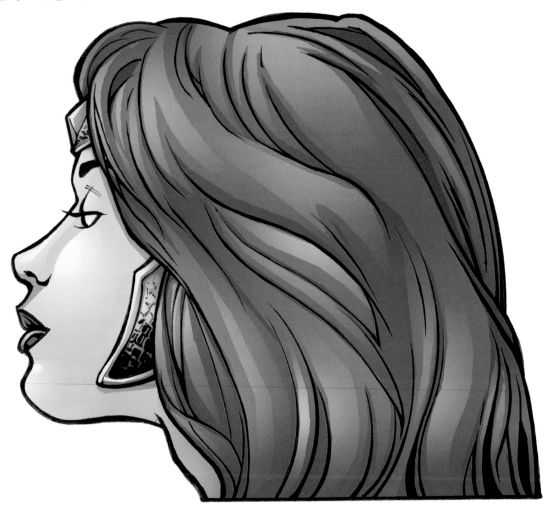

UNDERSTANDING THE CONTOURS OF THE FACE

SHARPEN THOSE PENCILS, BECAUSE WE'RE GOING TO CREATE AN ASSORTED CAST. The step-by-step constructions will help you to visualize the form, planes, and contours of the face. But it's not necessary to draw every contour line you see on each construction step. They're just included to show you the concept.

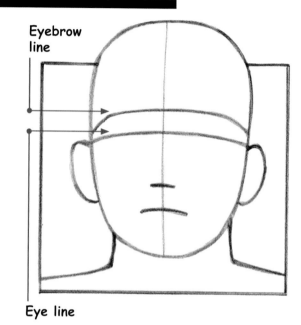

Eyebrow line

Eye line

TEEN SUPERHERO

The young hero type that stars in action-fantasy, sci-fi, and steampunk comics is clean cut and bright eyed. Typical of youthful characters, our ace pilot has a large forehead and soft jaw. He's not hard and chiseled looking.

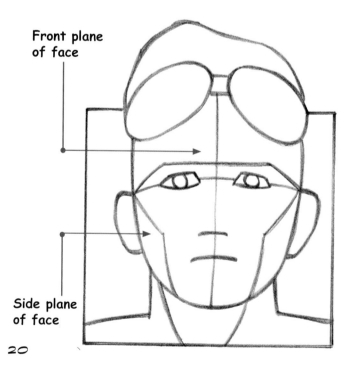

Front plane of face

Side plane of face

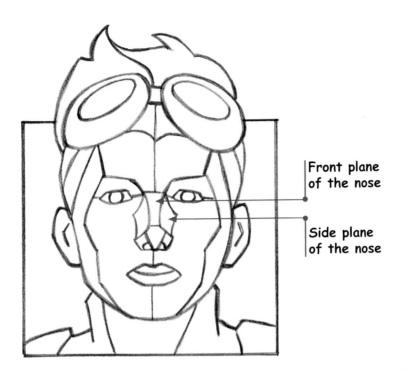

Front plane
of the nose

Side plane
of the nose

FINISHING UP

The construction phase, in steps 1-3, is used to help you create a rough drawing that looks solid. You can lose the construction lines in the final step, and the face will still look solid.

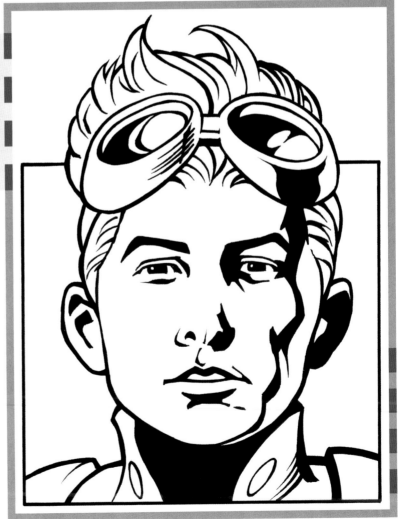

SAVAGE STARSHIP COMMANDER

Older than the teen hero, this character provides an example of adult male facial contours, which are more angular than those of young characters. As our character matures, the bones in his face become more prominent and his skin grows tighter. This results in more defined facial planes.

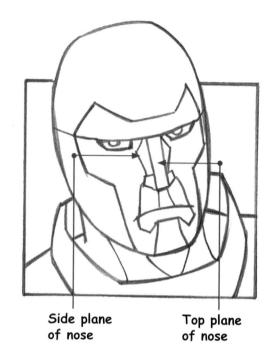

Side plane of nose

Top plane of nose

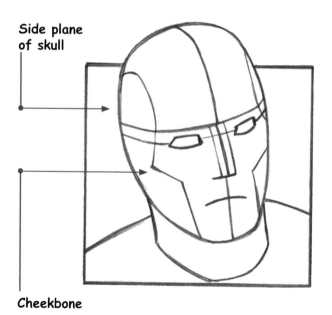

Side plane of skull

Cheekbone

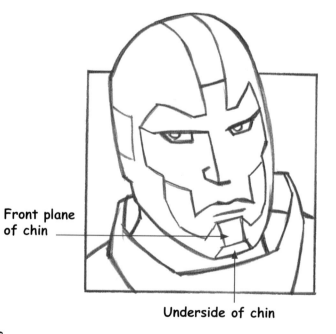

Front plane of chin

Underside of chin

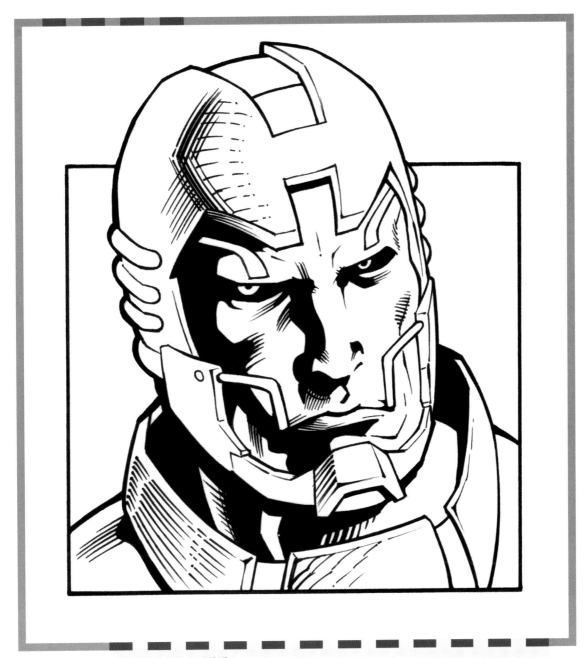

THE HELMET

Encasing a head in a top-to-bottom metal helmet is a way of dehumanizing a character, making him (or her) seem as much machine as human. The helmet is the character's life-support system, melding with the head into a single biomechanical unit. That, plus the fact that the whites of his eyes are black (that white area you see here is the iris), gives him a cruel, otherworldly appearance.

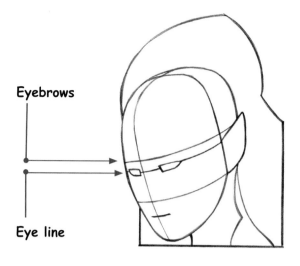

Eyebrows

Eye line

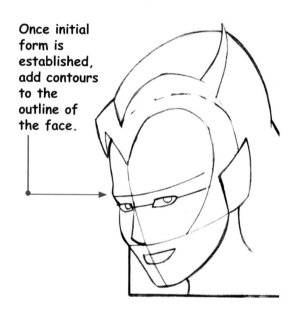

Once initial form is established, add contours to the outline of the face.

SCI-FI ALIEN QUEEN

Sci-fi is where character designs mix primitive and futuristic motifs to produce fantastical characters. The queen from a distant planet, seductive and alluring, is an ever-popular standard in comics.

The sharp eyebrows with a high arch add a wicked look to her expression. The ear curves up. The headdress has hornlike prongs to repeat the theme of the pointed ears. Repeating themes is one way artists create a cohesive character design.

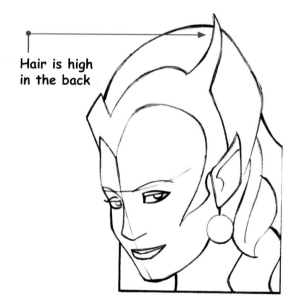

Hair is high in the back

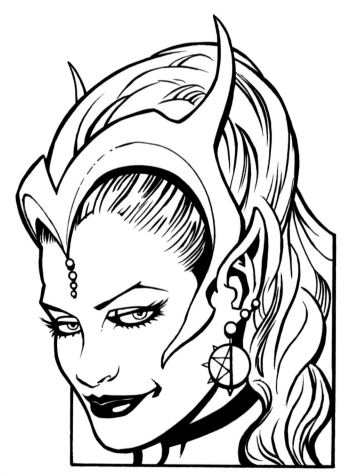

THE NEW LOOK OF CRIME (WITH SHADOW)

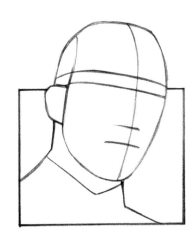

The old-style, fat, cigar-chewing crime boss has been replaced with a new, sleeker character. He's younger and more ruthless than his predecessor. These thieves are into arms smuggling and international intrigue. They don't deal in handguns, but in missile launchers, and they sell to the highest bidder. Never to be trusted, not even by their closest associates, the double cross is in their blood.

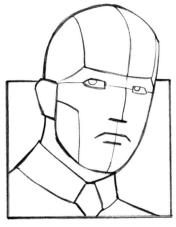

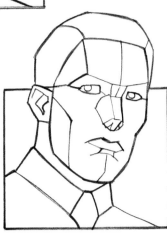

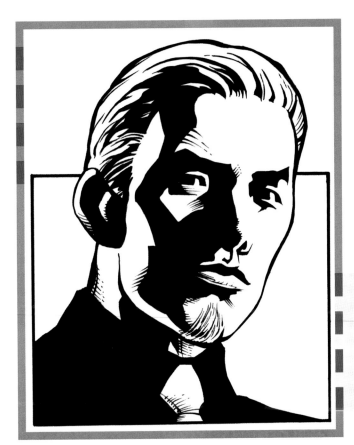

THE TRAPPINGS OF A "BUSINESSMAN"

The stare is a sideling glance that creates a suspicious look. The hair is slicked back, and he wears a goatee. Give him a collar and a tie; he fancies himself a "businessman."

COMIC BOOK-STYLE FEATURES

COMICS ARE FILLED WITH CLOSE-UPS AND EXTREME CLOSE-UPS that show facial features drawn in great detail. Sometimes the eyes or the mouth are the only element in a panel. Or, the close-up of the face might be very tight. Spend a little time copying the panels on these pages. They'll give you the chance to really focus on facial features.

EYES

The eyes communicate a character's inner thoughts. Primitive thoughts like, "I've got to stop him" or "Please . . . God . . . No!" can, and should, be conveyed with a single flash of the eyes.

The way you draw the eyes determines the character's identity. For example, beady eyes are used for villains. Large pupils connote innocence and youth. Almond-shaped eyes with heavy eyelashes make for attractive female characters. Rectangular eyes with heavy eyebrows are often seen on heroes.

Male Eyes

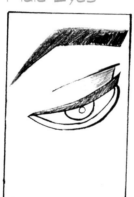

In the *down angle* (meaning we're looking down at the character from above), both eyelids curve upward.

The eyebrow has mass and depth, as indicated by different planes.

In profile, set the eye back from the bridge of the nose.

Female Eyes

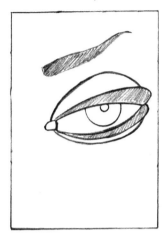

The eyelashes brush away from the eye. The upper eyelid is horizontal, but the lower eyelid is curved.

In the down angle, the eyelids curve up—even when the eye shows thick eyelashes.

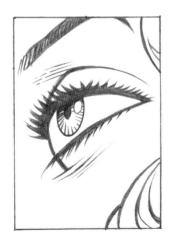

In the up angle, the eyelids curve downward.

THE NOSE

The nose is formed from a series of planes intersecting at different angles. It has mass and depth. Most beginning artists only draw one line to indicate the bridge of the nose. But you can't show mass if you only use one line. Give the bridge of the nose some thickness, as seen here in the front and ¾ views. And remember, since the nose protrudes from the face, it casts a shadow on the upper lip.

Articulated, for Men

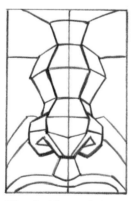 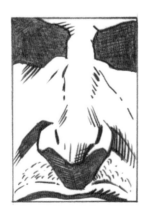

The nose has a top and a side to it, which is something you should keep in mind even in the profile.

 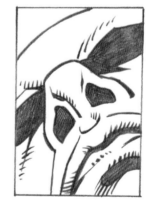

Shadows are added once the basic structure is in place.

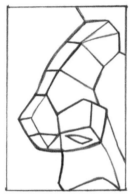 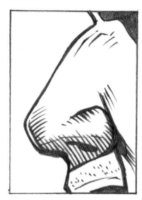

The bridge of the nose widens out in the middle. The tip of the nose casts a shadow that helps to convey form and three-dimensionality.

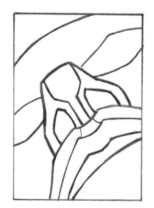

This extreme pose is not all that uncommon. We often look up at heroic characters.

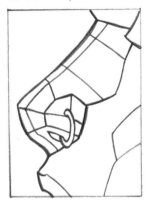
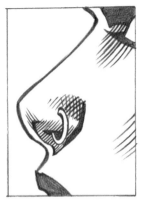

The lips and eyes should be the focus of the female face. So our job is to create a subtle nose that doesn't draw attention to itself.

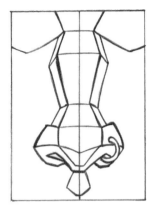

The bridge of the comic book woman's nose is thin. Some artists leave it out altogether, just drawing the nostrils. If you choose to include it, shade one side plane of the nose to highlight its narrow sleekness.

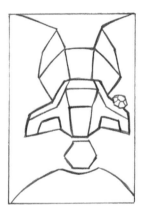

Use shadow, rather than a hard line, to show the bridge of the nose, softening the look.

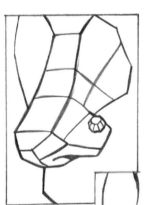

The nostrils must be kept small, likewise the tip of the nose.

THE MOUTH

The mouth has a unique quality in that it stretches and contracts to create a wide range of expressions. Generally, more severe mouth positions will also include a prominent look at the teeth.

The Men

These are the basic planes of the mouth and chin.

 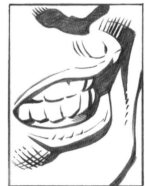

The mouth pulls back at either side to form expressions.

 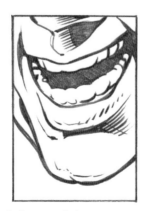

The mouth wraps around the teeth in a curved line.

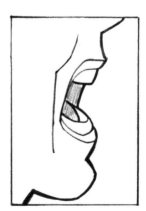

A stretched-open mouth is accompanied by stretch lines on the face.

Some of the defining lines between the teeth are only partially articulated, allowing the teeth to blend together. This creates a gleaming, brilliant look.

 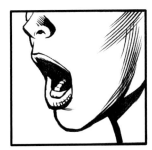

The lips are usually drawn in different thicknesses. Either the top lip is fatter than the bottom or vice versa. This asymmetry adds to the allure.

 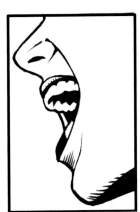

In certain views and expressions, you see both the inner and outer sides of the teeth.

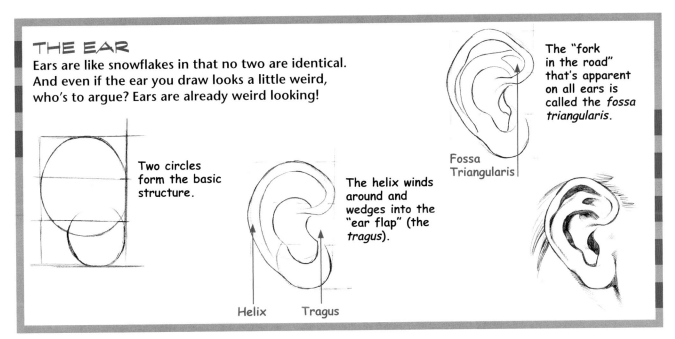

THE EAR

Ears are like snowflakes in that no two are identical. And even if the ear you draw looks a little weird, who's to argue? Ears are already weird looking!

Two circles form the basic structure.

The helix winds around and wedges into the "ear flap" (the *tragus*).

The "fork in the road" that's apparent on all ears is called the *fossa triangularis*.

Fossa Triangularis

Helix Tragus

DIFFERENT HEAD SHAPES AND TILTS

NOW LET'S PRACTICE DRAWING DIFFERENT CHARACTER HEADS at different angles. For this, we rely on the basic construction.

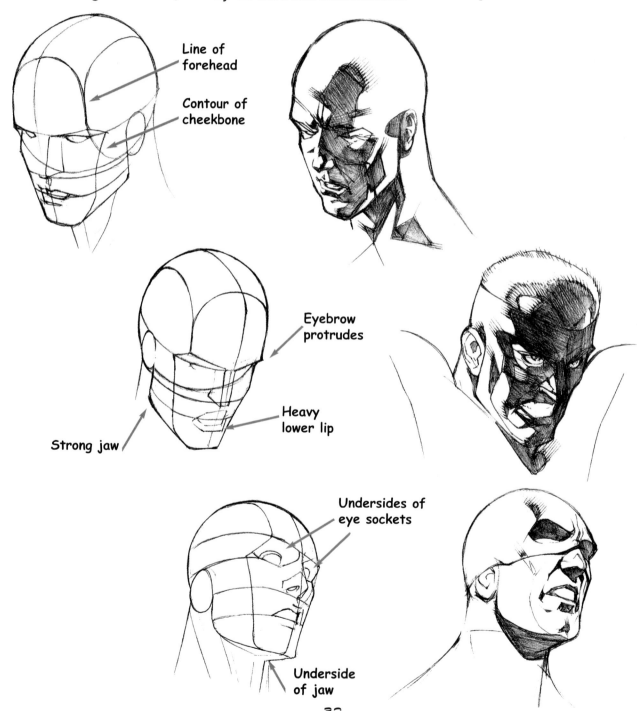

Line of forehead

Contour of cheekbone

Eyebrow protrudes

Strong jaw

Heavy lower lip

Undersides of eye sockets

Underside of jaw

32

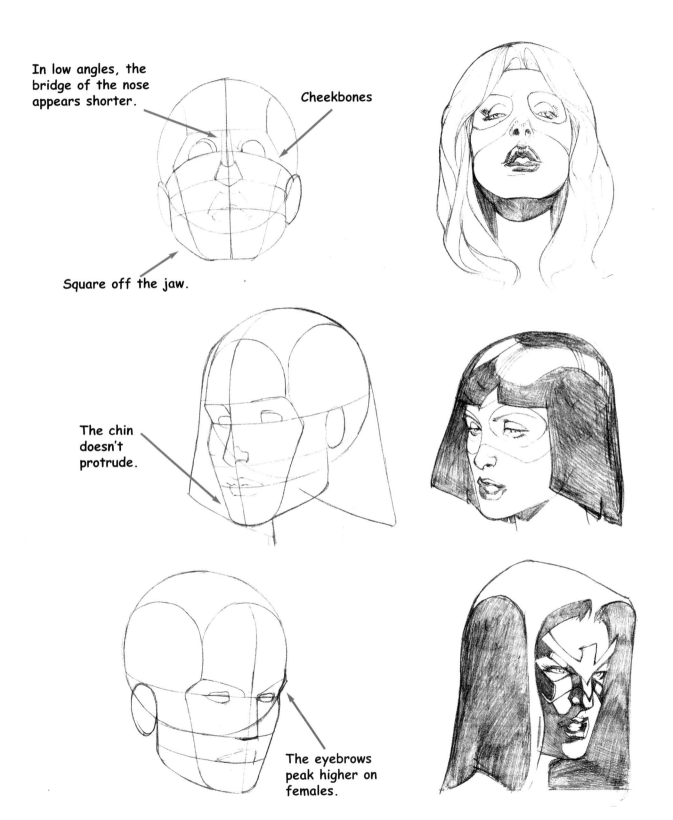

In low angles, the bridge of the nose appears shorter.

Cheekbones

Square off the jaw.

The chin doesn't protrude.

The eyebrows peak higher on females.

33

POPULAR EXPRESSIONS

Good guys aren't always ruggedly determined. And villains aren't always laughing with evil delight. Those are stereotypical emotions and expressions. However, to breathe life into characters, you must make them more than one-dimensional. That means that insecurities and frustrations also dog superheroes, just as they do us mortals. Below, you'll find some classic expressions you can use.

Determined

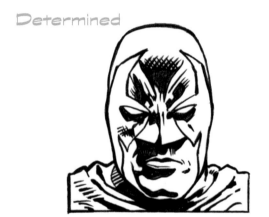

This is the most popular expression for the single-minded superhero. Note the tight bottom lip and jutting chin.

Furious

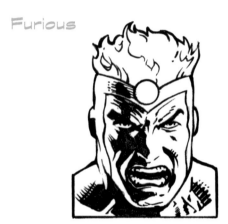

It's the springboard emotion that propels both superheroes and villains to seek revenge—open mouth, teeth evident. Note the flared nostrils.

Scheming

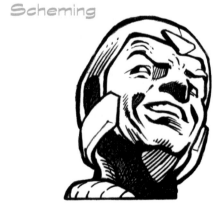

Here's a great expression for villainous characters. Note the narrow eyes with the sidelong glance.

Laughing

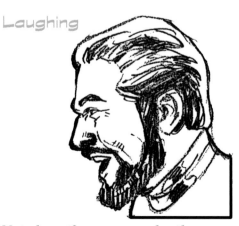

Note how the crease under the eyes pushes upward.

Brooding

Don't let the speech balloon do all the work; your character's expressions should reflect what's being said and felt. Note the angry eyebrows and tight mouth.

Amazed

This is a good expression when your character witnesses something spectacular. Note the wide-eyed expression combined with the wide-open mouth.

Sinister Smile

This is the diabolically delicious thing about villainous characters: They enjoy evil so much. This expression combines a big smile with angry eyes.

Fighting Mad

There's hardly a comic book in print that hasn't featured this expression in one of its stories. Grit the teeth and wrinkle the bridge of the nose.

Stunned

Here, the mouth opens wide, and the eyes open even wider.

Remorseful

A light tilt of the head works to indicate the regretful state of the character. The eyebrows rest close to the eyes.

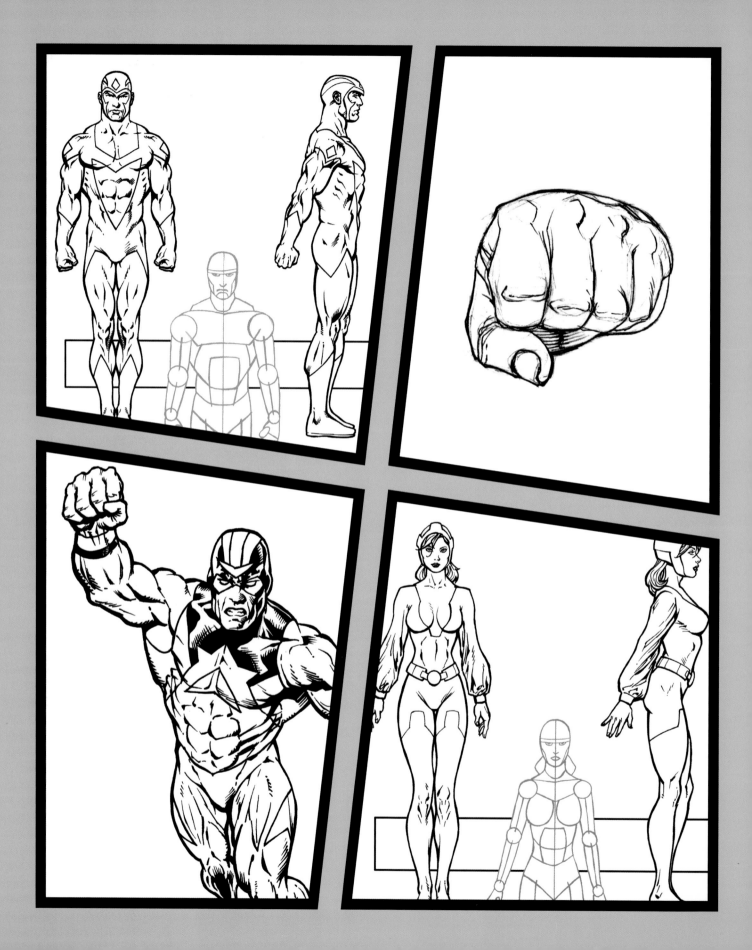

CHAPTER 2

THE SUPERHERO BODY

TO GET A GOOD HANDLE ON DRAWING THE FIGURE, we'll start off with some anatomical basics. But we won't get bogged down with muscle charts. We'll quickly move on to step-by-step figures and costumes.

THE SKELETON INSIDE THE FORM

IT'S NOT JUST THE MUSCLES but also the *skeleton* that gives the body its impressive stature. For example, if the character has wide shoulders, a deep chest, and a narrow waist (the typical superhero build), then this is formed by widely positioned scapulas (shoulder blades), broad clavicles (collarbones), an enlarged rib cage, and a small pelvis.

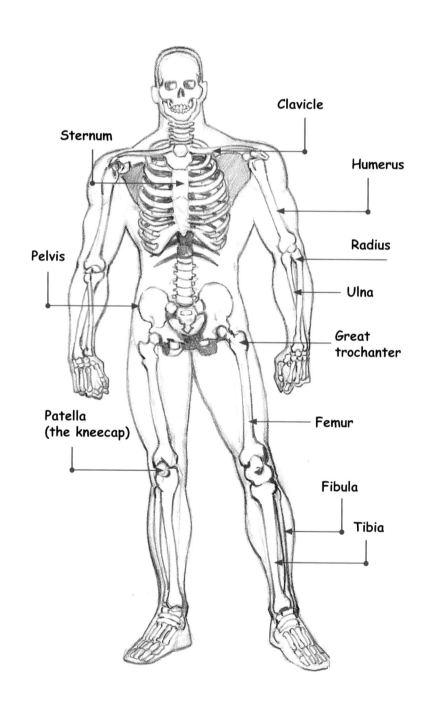

Clavicle

Sternum

Humerus

Radius

Pelvis

Ulna

Great trochanter

Patella (the kneecap)

Femur

Fibula

Tibia

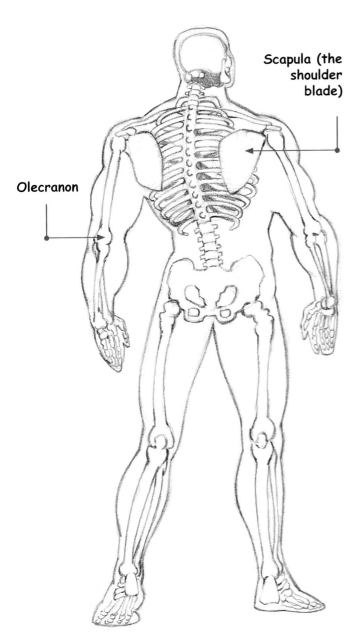

Scapula (the shoulder blade)

Olecranon

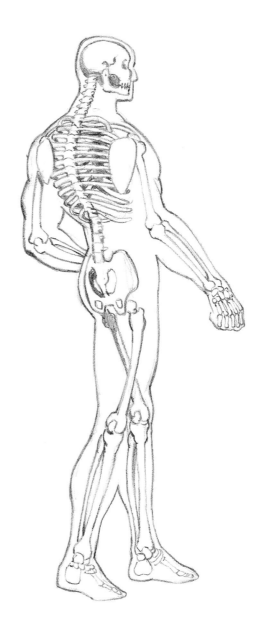

The leg bones are heavier and, therefore, thicker than the bones of the arms. They have to be studier, because they're supporting all the weight of the body. The spine is thickest by the pelvis and gets thinner as it travels up toward the neck.

The bones of the body are not "ruler straight." You'll detect a slight curve to the arms, legs, and collarbones in these diagrams. This curving is what gives life to the body. Even the spine—*especially* the spine—has a natural curve to it.

SIMPLIFYING THE BODY CONSTRUCTION

NOW THAT WE'VE COVERED SOME ANATOMICAL INTRICACIES of drawing the muscles, we'll go over the broad strokes—how you actually begin your comic book figure. Start with a basic framework, then introduce the details.

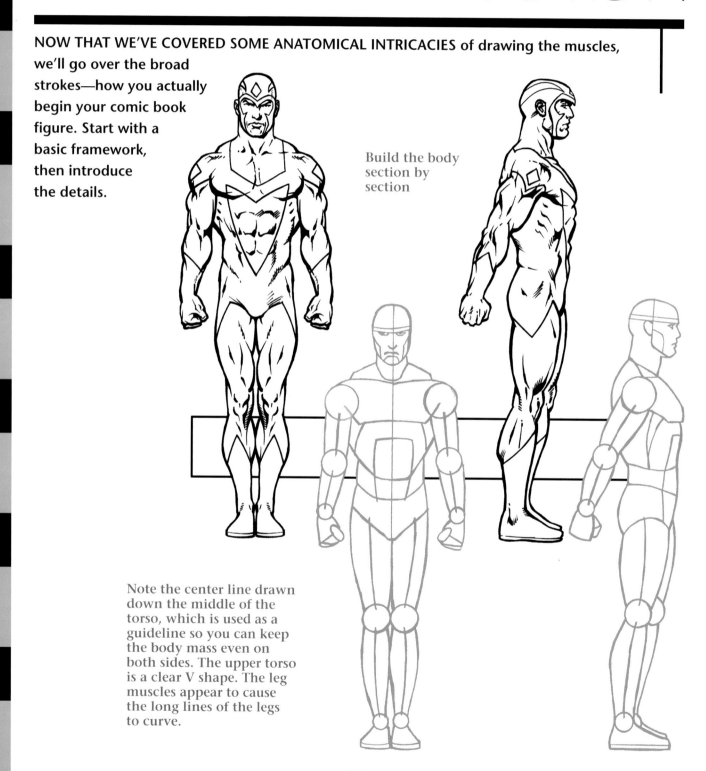

Build the body section by section

Note the center line drawn down the middle of the torso, which is used as a guideline so you can keep the body mass even on both sides. The upper torso is a clear V shape. The leg muscles appear to cause the long lines of the legs to curve.

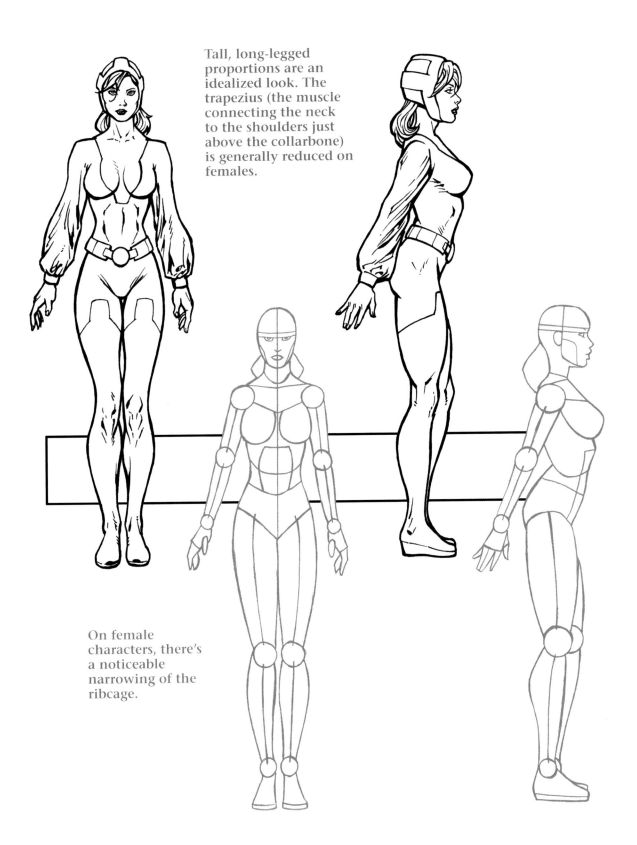

Tall, long-legged proportions are an idealized look. The trapezius (the muscle connecting the neck to the shoulders just above the collarbone) is generally reduced on females.

On female characters, there's a noticeable narrowing of the ribcage.

HANDS

THE FINGERS CREATE THE "EXPRESSIONS" of the hand. They flex, point, and extend with great yearning. Each finger has three joints, which means it will have three bends in it. The thumb has three joints also, but only two are visible. The knuckles on men are always emphasized. Be sure to indicate a large area for the palm heel. And when the hands are drawn in close-up shots, you can add fingernails. When they're part of a smaller figure, it's best to leave the fingernails off.

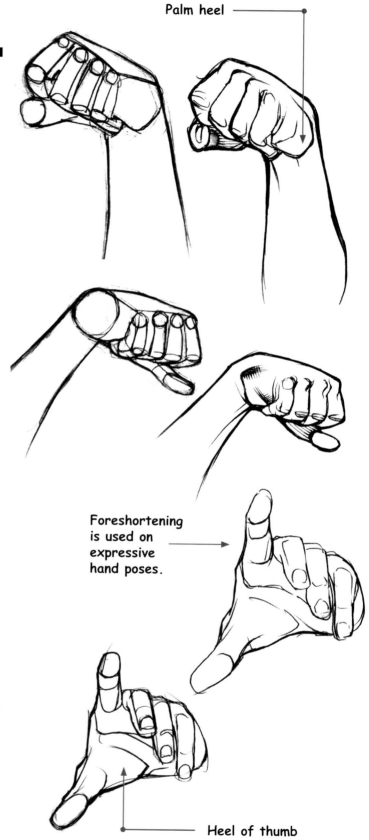

Palm heel

Foreshortening is used on expressive hand poses.

Heel of thumb

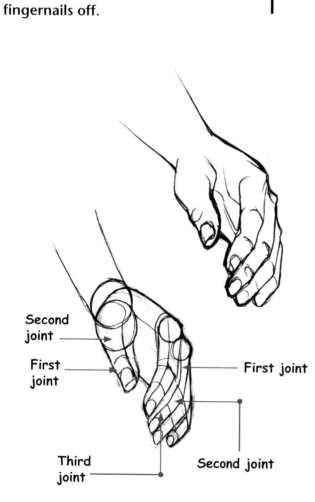

Second joint

First joint

First joint

Third joint

Second joint

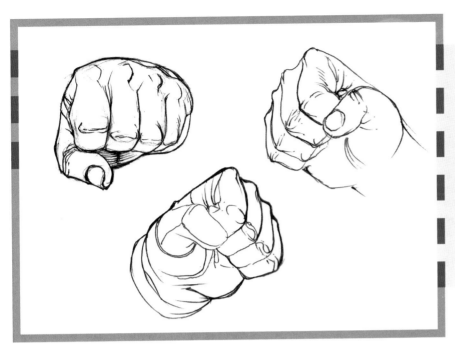

FISTS

Fists are great mallets, used to pound bad guys into submission. Fingers get a little tricky to draw when they're wrapped around the palm into a tight fist; it's important to be sure that you're indicating each finger joint in the fist. If the fist looks wrong, count up the joints on the fingers. Are you showing three distinct angles to each digit? If not, you left out a joint.

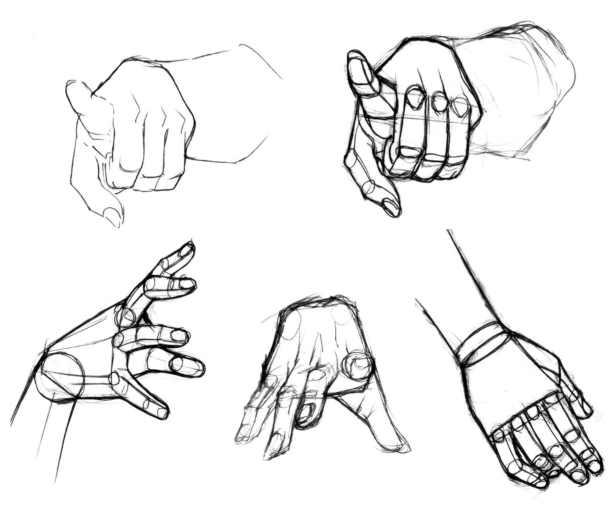

FEET AND FOOTWEAR

I'VE INCLUDED DRAWINGS OF FEET in all sorts of positions, which you can use as a chart to eyeball anytime you need a reference. There are also feet in footwear: superhero boots, regular shoes and boots, and high heels. Designing superhero boots is like designing any part of a comic book character's costume: You've got to make it dramatic. Add buckles, cuffs, armor plates, an insignia, or decorative trim.

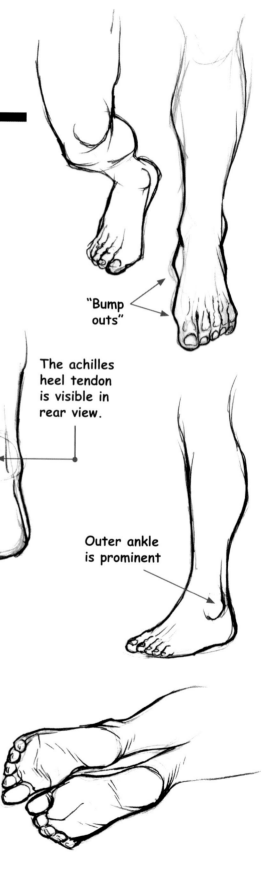

"Bump outs"

The line of the big toe travels up to the inner ankle.

The achilles heel tendon is visible in rear view.

The big toe can stand alone, but group the four smaller toes together.

Outer ankle is prominent

44

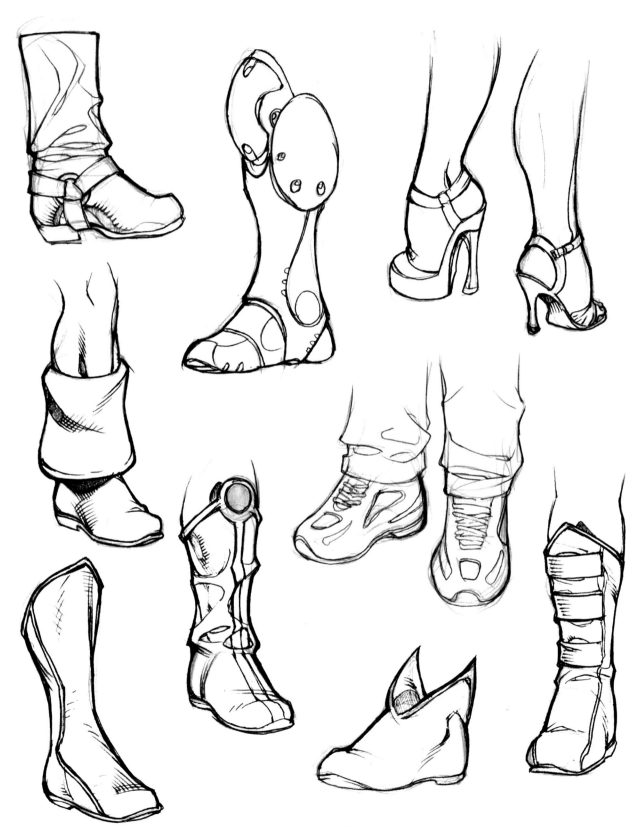

CHAPTER 3

COMIC BOOK FORE-SHORTENING AND BODY DYNAMICS

FORESHORTENING SIMPLY MEANS EXAGGERATING how near or far things appear—like a giant fist coming at the reader. It adds extra power to your drawings, and if you've read comics, you've seen this technique hundreds of times in dramatic poses. Foreshortening adds extra "oomph" even to regular poses. Sometimes the effect is great; sometimes it's subtle. It's one more technique you can use to create impact. Let's see how it's done.

FORESHORTENING BASICS

LET'S START WITH THE CLASSIC HEROIC STANCE. This may seem like a basic pose, but even here, we've put foreshortening to use. The superhero doesn't just stand there facing the reader head-on. You want him to look noble and triumphant, so you draw him in a slight "up angle." And since we're looking up at him, some foreshortening is required to make this angle effective. The legs are large, because they're at our eye level. But the upper body is truncated slightly. And the head, being the farthest part from us as we look up at it, is smaller still.

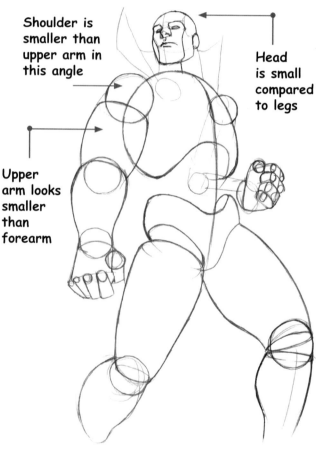

Shoulder is smaller than upper arm in this angle

Head is small compared to legs

Upper arm looks smaller than forearm

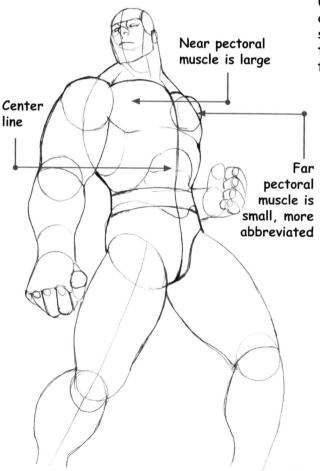

Near pectoral muscle is large

Center line

Far pectoral muscle is small, more abbreviated

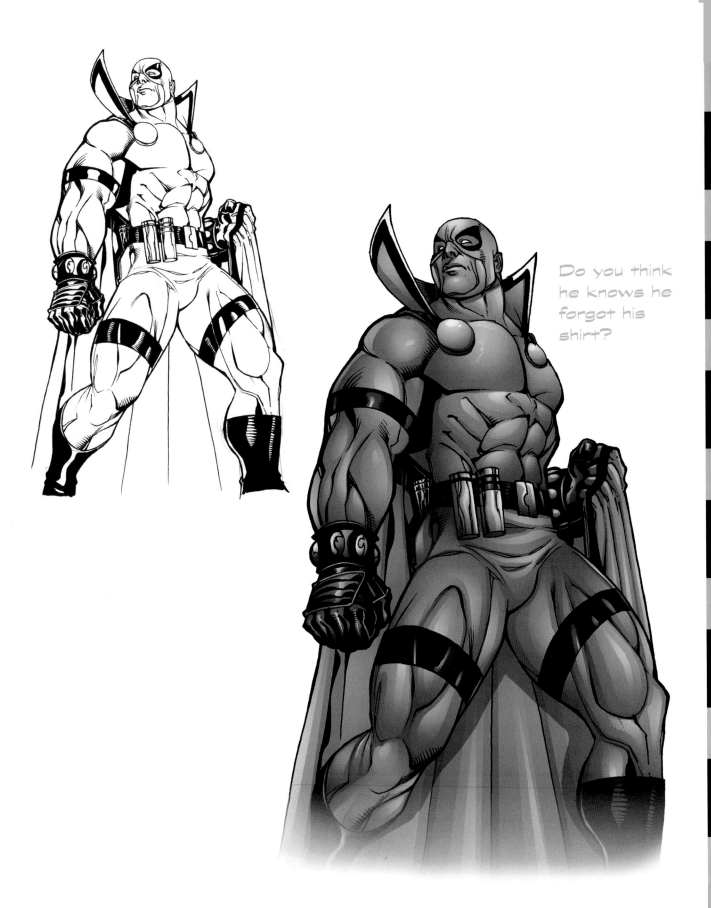

Do you think he knows he forgot his shirt?

FLYING AT US

HERE'S ANOTHER CLASSIC COMIC BOOK POSE. Instead of drawing him flying left to right across the page, you'll get more power by having him fly toward the reader, who almost has to duck out of the way! You can open his hands if you want but closed fists make a cool, modern look.

Note how much overlapping is going on with the arms. They've "flattened out" due to foreshortening. His head is lowered onto the shoulders, which means we can't see his neck at this angle. And the legs are eliminated below the knees.

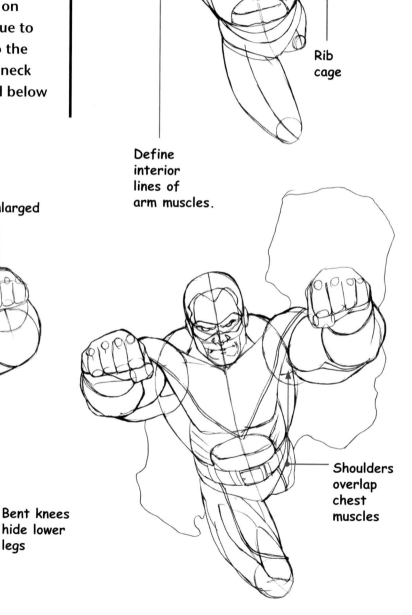

Rib cage

Define interior lines of arm muscles.

Fists are enlarged

Each section of the arm is defined carefully.

Bent knees hide lower legs

Shoulders overlap chest muscles

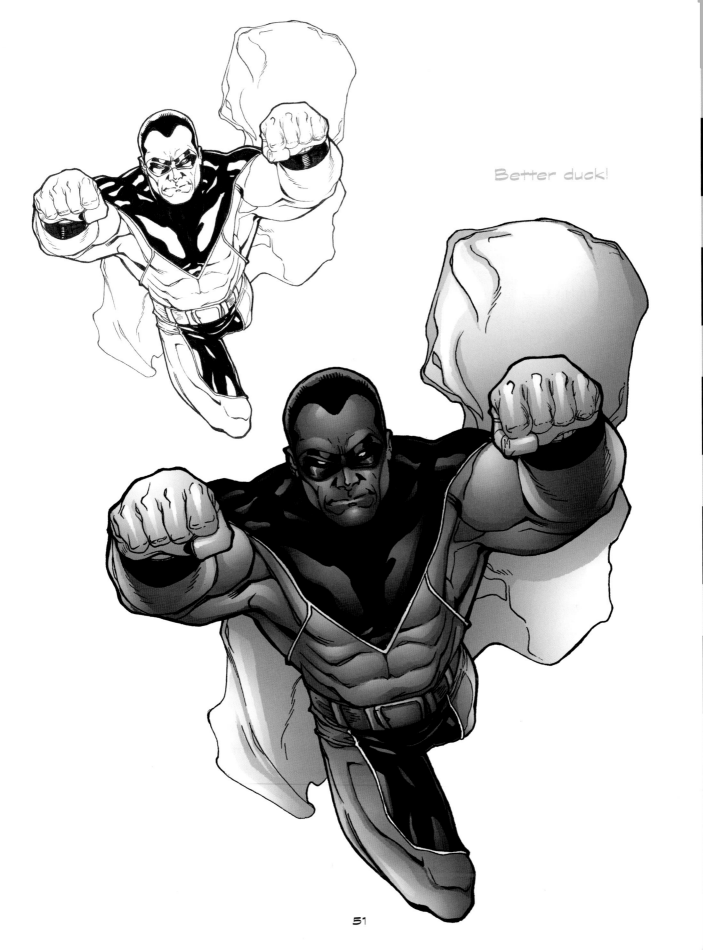

Better duck!

SWINGING AND LEAPING

MOST OF THE FORESHORTENING OCCURS IN THE FRONT LEG, which is coming toward the reader. Notice that the upper thigh of the front leg is short. Compare this to the far leg, which, because it is not coming toward us, is not foreshortened. The same deal with the straightened arm, which is coming toward us and is therefore foreshortened.

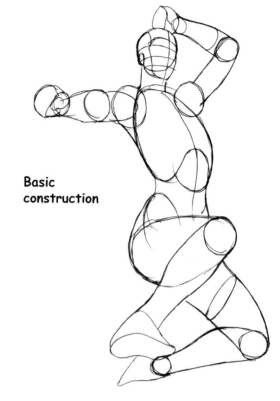

Basic construction

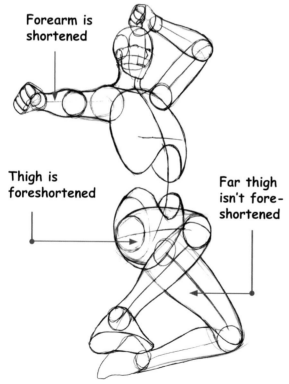

Forearm is shortened

Thigh is foreshortened

Far thigh isn't fore-shortened

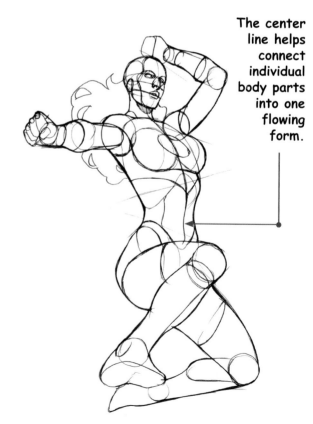

The center line helps connect individual body parts into one flowing form.

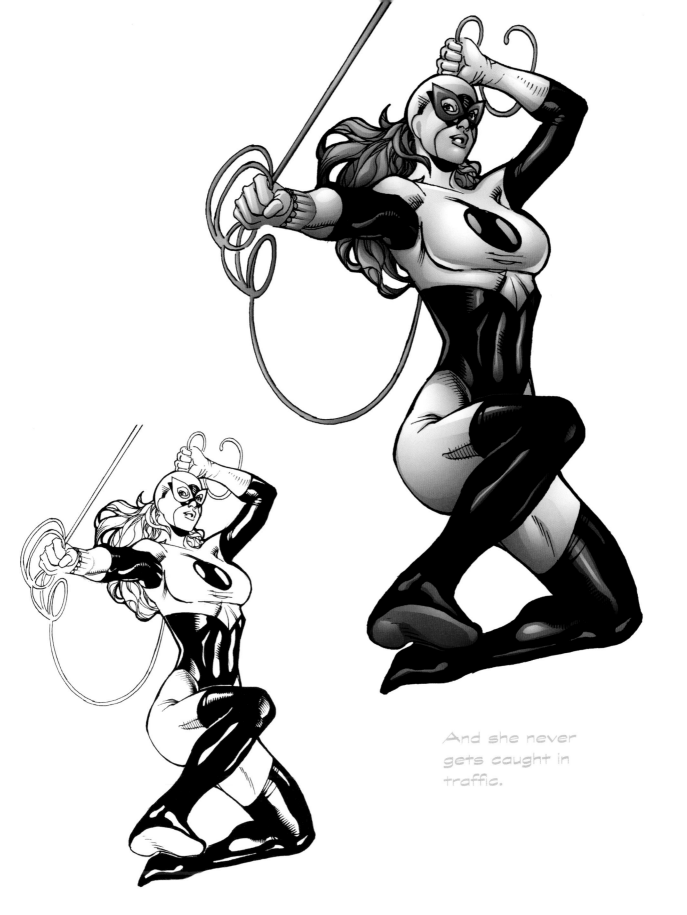

And she never gets caught in traffic.

THE RUNNING PUNCH

THIS IS ABSOLUTELY CLASSIC FORESHORTENING ACTION. One arm is out right in your face; one arm is back. The bent leg is driving forward; the other is back. So you can begin to see that there are no fixed sizes to the body parts in a foreshortened pose. In the running punch, the arms swing in the opposite directions of the legs on the same sides of the body, just as in a walk or a run.

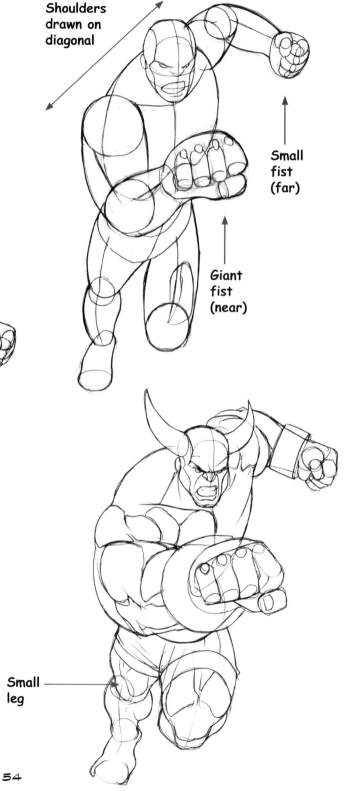

Shoulders drawn on diagonal

Small fist (far)

Giant fist (near)

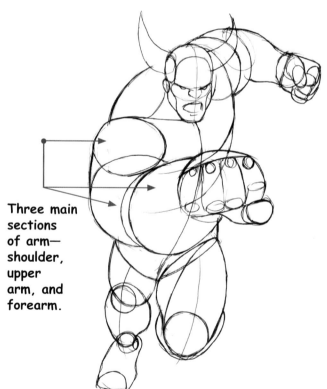

Three main sections of arm— shoulder, upper arm, and forearm.

Small leg

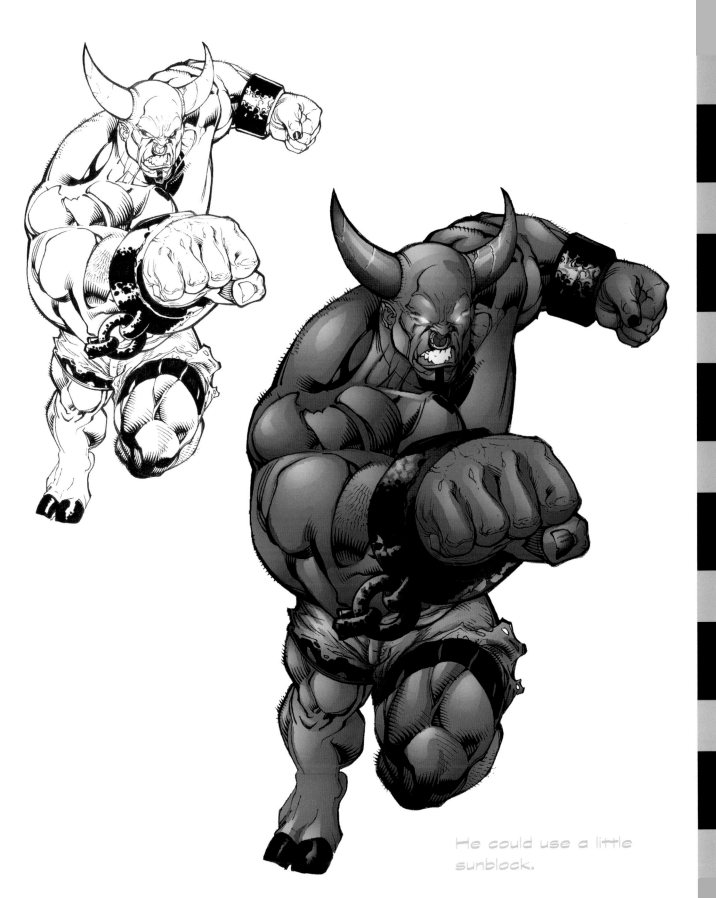

He could use a little sunblock.

GETTING SOCKED!

THROWING A PUNCH IS ONLY HALF OF A
FIGHT SCENE—you've also got to draw the guy
who's reeling from the blow. Notice that his
entire body goes limp as he receives the punch.
His head leads the way, with his arms and legs
coming in tow, a beat behind due to inertia.
The top half of his body is enlarged, while the
bottom half is reduced in size.

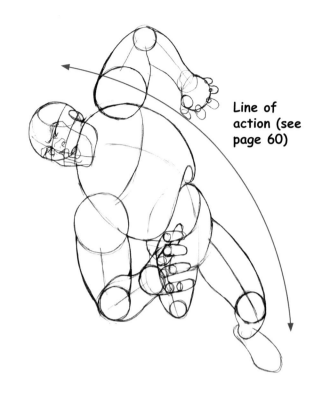

Line of
action (see
page 60)

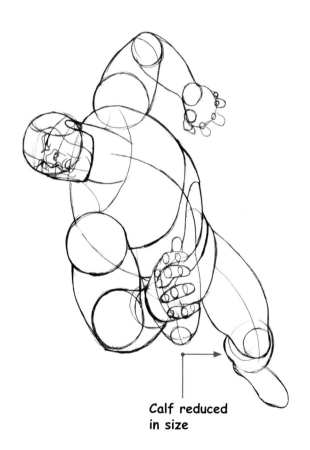

Calf reduced
in size

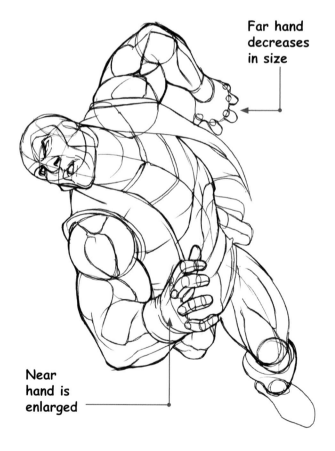

Far hand
decreases
in size

Near
hand is
enlarged

Next time,
keep your
hands up.

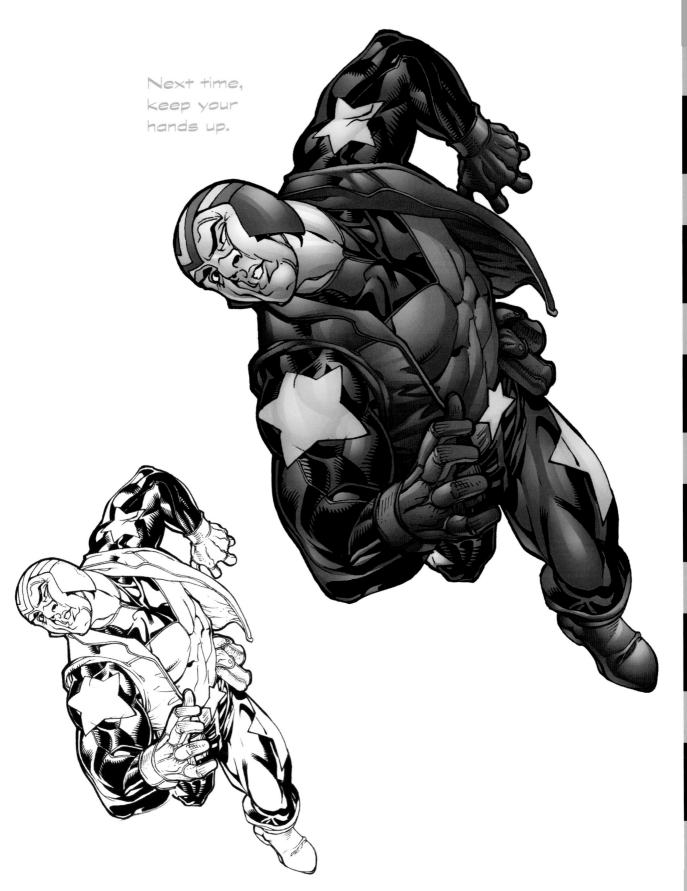

BALANCE AND MOMENTUM

NOTHING DETRACTS FROM AN IMAGE so much as a character drawn slightly off balance. The basic concept for maintaining balance is that the body weight must be distributed evenly on either side of the point of equilibrium. The basic concept for showing momentum is that the faster a character moves, the further forward the body leans.

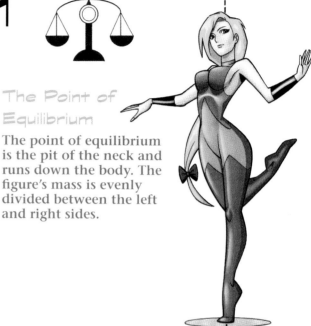

The Point of Equilibrium

The point of equilibrium is the pit of the neck and runs down the body. The figure's mass is evenly divided between the left and right sides.

Off Balance

Since more of the character's mass falls to the left (our left) of the point of equilibrium, the figure is off balance.

Balanced

Another technique is based on a triangle. The pose travels down to a single point.

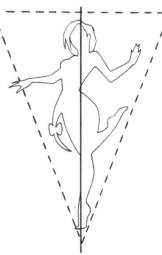

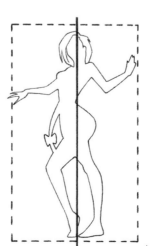

Balanced

Sketching shapes around the figure as a guide helps highlight whether or not a figure is correctly balanced. Here, the weight is evenly divided between left and right sides.

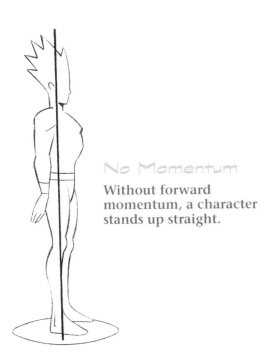

No Momentum

Without forward momentum, a character stands up straight.

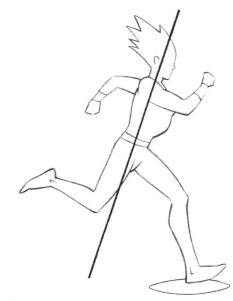

Momentum

The body leans forward when the character runs.

Extreme Momentum

The faster the run, the farther forward the character leans.

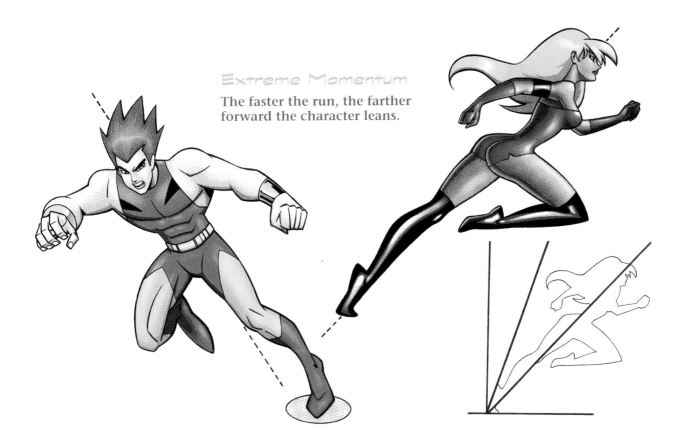

THRUST

EVERY POSE HAS A BASIC UNDERLYING THRUST. This is called the *action line* and is especially apparent on *action poses*. This line is loosely sketched in as a guideline at the beginning of a drawing. By creating a line for the action to follow, you streamline your pose and simplify (and clarify) the direction.

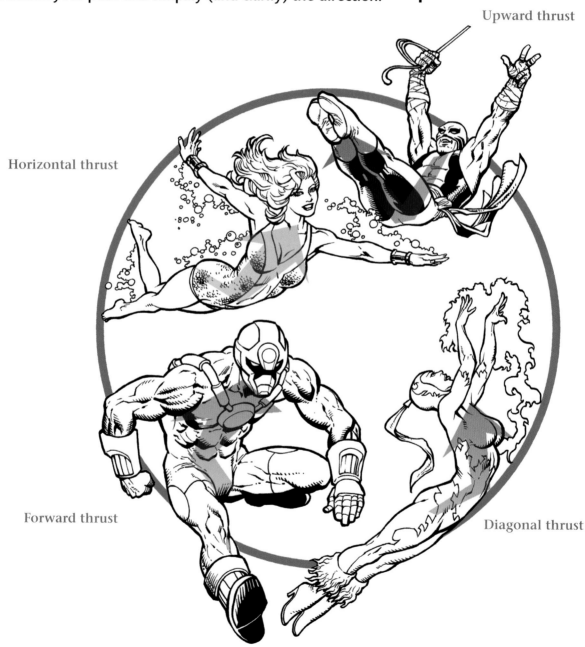

Upward thrust

Horizontal thrust

Forward thrust

Diagonal thrust

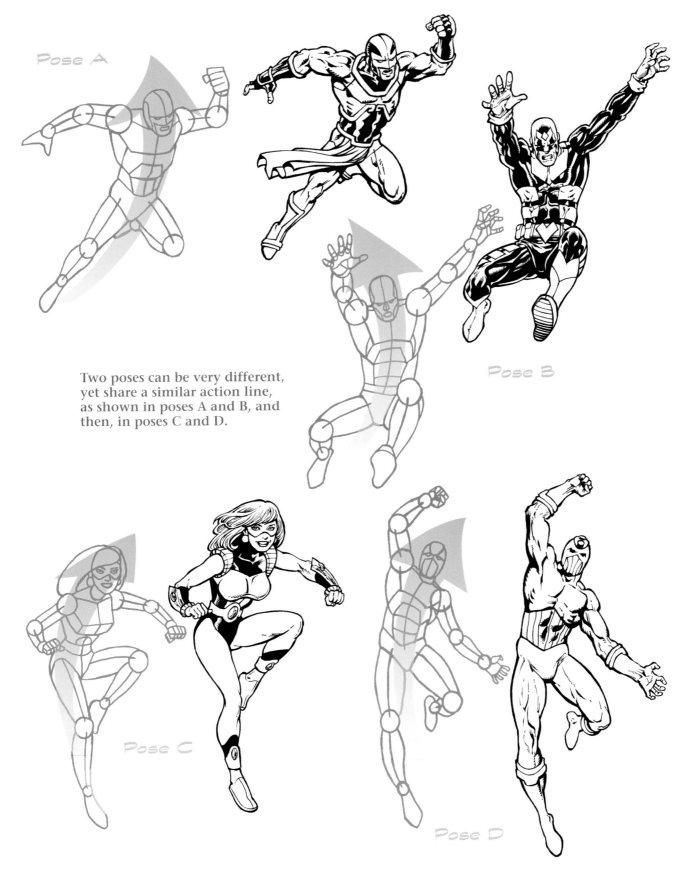

Pose A

Pose B

Pose C

Pose D

Two poses can be very different, yet share a similar action line, as shown in poses A and B, and then, in poses C and D.

SHOULDER AND HIP DYNAMICS

HERE'S A TECHNIQUE YOU'LL WANT TO USE OFTEN. It brings poses to life. When you initially sketch the figure, use one horizontal bar to indicate the line of the shoulders and another to indicate the line of the hips. Draw these two lines so that they're not parallel to each other. This stretching and pulling of the torso is quite dramatic.

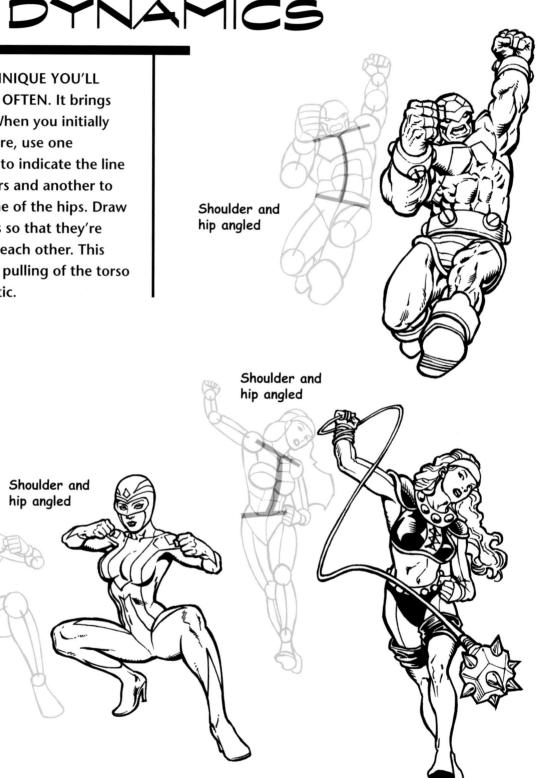

Shoulder and hip angled

Shoulder and hip angled

Shoulder and hip angled

TORSO TWIST

Another secret for making a pose more dynamic is to twist the upper torso. The chest rotates with the shoulders. It's a dramatic way to show motion.

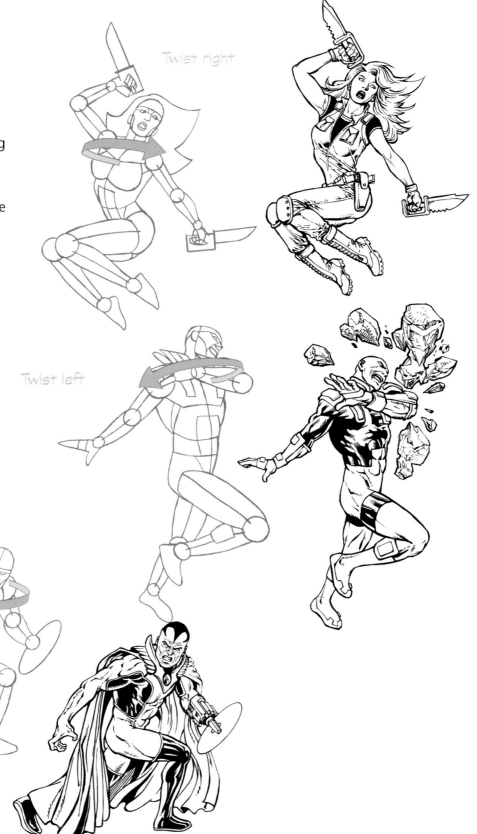

Twist right

Twist left

Twist back

THE GOOD GUYS

SUPERHEROES IN COMICS HAVE GOT THEIR PROBLEMS. Superpowers aren't just a gift. They also make you different, an outsider. And you've got to continually restrain yourself from using those powers.

Superheroes also suffer from poor day-job performance due to late nights battling super-criminals. Plus, the girl he loves doesn't have a clue who he really is. Which world does he belong to? Hers or the streets he protects? These guys are also prone to bouts of despair, which gives comics gravitas. They usually win in the end, but these heroes also suffer their share of defeats and setbacks along the way—otherwise, where would the suspense come from?

CLASSIC CRIME-FIGHTERS

THIS POSE IS A FAN FAVORITE. It shows our hero watching over the city. Draw him broad on top, arms at the ready, with feet wide apart (about shoulder width).
He's drawn at a ¾ view, rather than a front view, because the angle makes it seem as though he's looking off into the distance.

This stage is basic. But the overall attitude or gesture of the pose is there from the start.

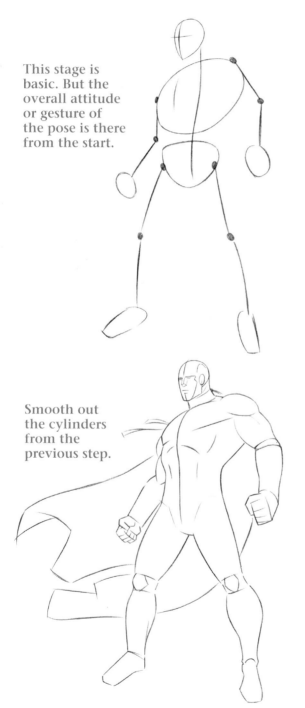

To give the body a sense of form and three-dimensionality, map out the main limbs using cylinders.

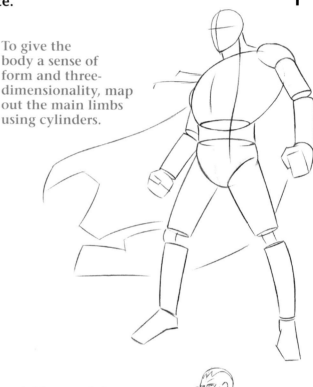

Smooth out the cylinders from the previous step.

Add some definition to define the major muscle groups.

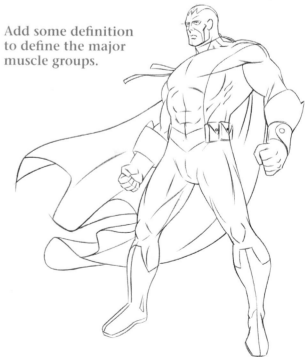

An easy method of shading is to thicken and darken the pronounced lines defining the musculature.

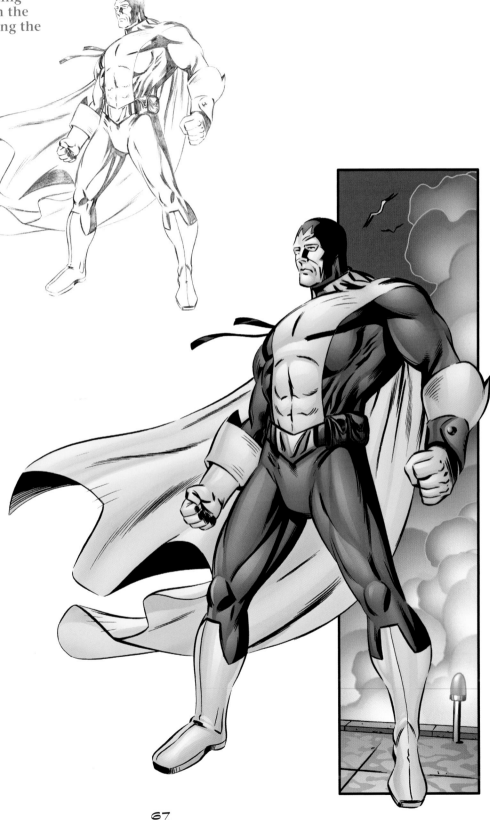

THE CRIME-FIGHTER COSTUME

Superhero costumes come in a wide variety of styles. A cape is the most obvious. It's not essential, but it adds drama. Formfitting boots and gloves are popular, as well as a belt and a facemask. You'll also want to add a symbol, design, or color pattern to the torso to create an identity.

CRIME-FIGHTING SUPERHEROINE

THIS CHARACTER TYPE MAY BE A MARTIAL ARTS EXPERT and possess hidden weapons. Here we show her landing on a rooftop. To add to the feeling of action, one foot makes contact with the ground while the other is still about to touch down.

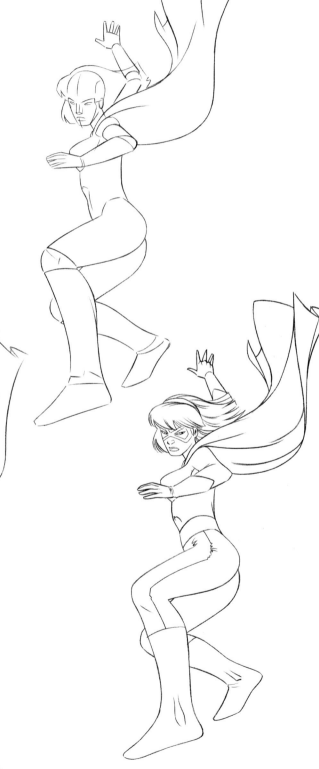

FOCUS ON THE FOOT POSITION.

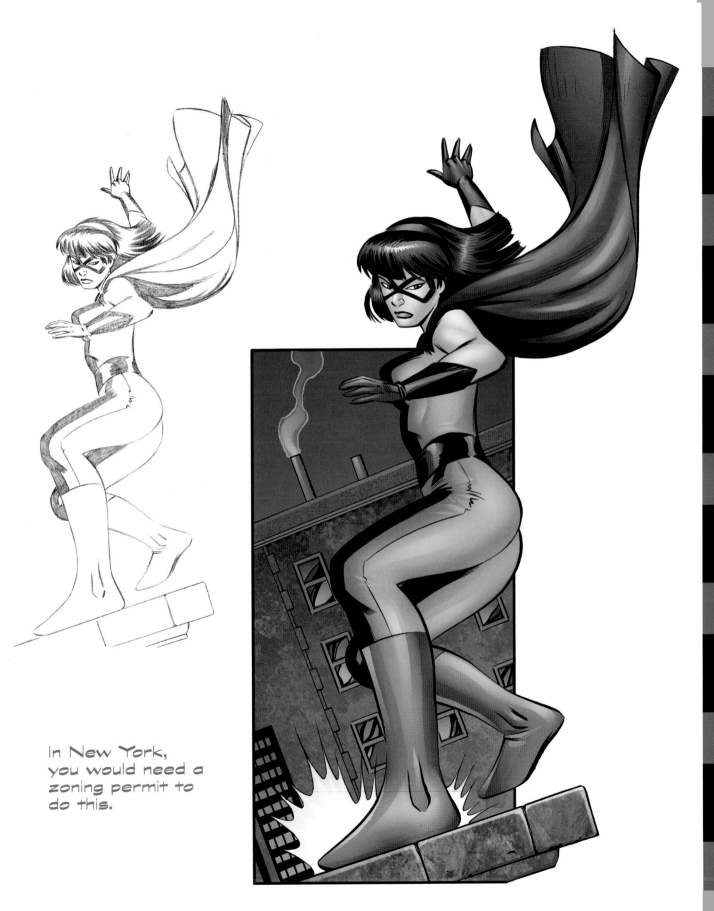

In New York,
you would need a
zoning permit to
do this.

SUPERHERO IN FLIGHT

FLYING POSES ALMOST ALWAYS USE A GREAT DEAL OF FORESHORTENING (which compresses the body). The use of foreshortening makes the pose easier to draw. That's because foreshortening eliminates parts of the body (the lower legs, in this instance) that you would otherwise have to draw.

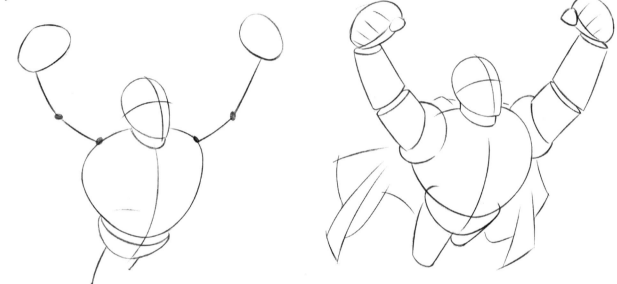

GREATLY EXAGGERATE THE CHEST, AND REDUCE THE SIZE OF THE LEGS.

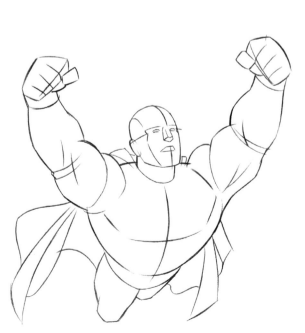

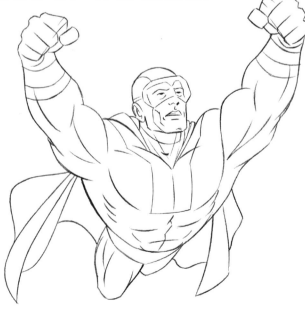

THE APPEAL OF FLYING

The take off and landing are the coolest flying poses. Flying horizontally across the page is less engaging.

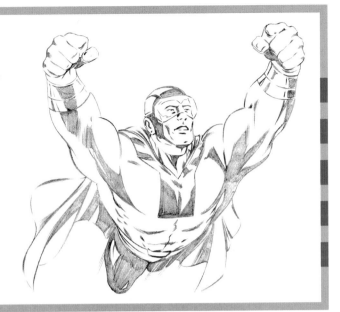

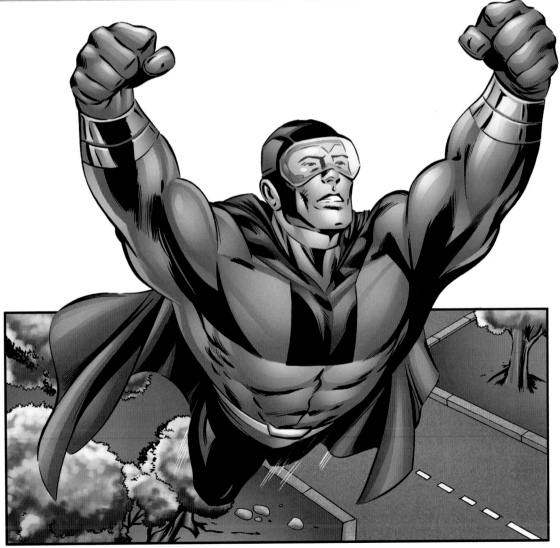

BIG BUDDY

EVERY TEAM OF SUPERHEROES NEEDS A GUY WITH MUSCLE to break things and toss a few cars at bad guys. That's where the big buddy-type character comes in. He's a gentle giant with a brute type of physique: massive upper body, huge hands, and a small head. The shoulders are drawn as wide as possible, and the quadriceps are the size of watermelons. The forward-reaching arm and the bent leg are severely foreshortened (compressed).

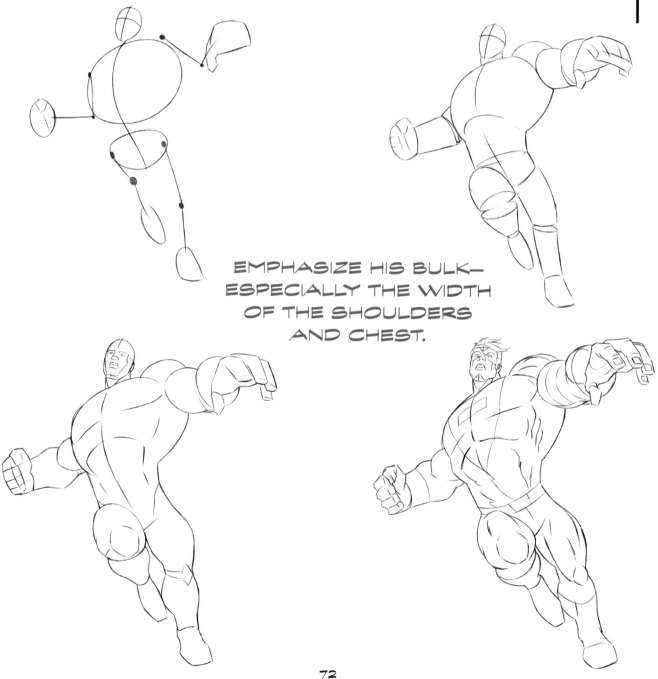

EMPHASIZE HIS BULK—
ESPECIALLY THE WIDTH
OF THE SHOULDERS
AND CHEST.

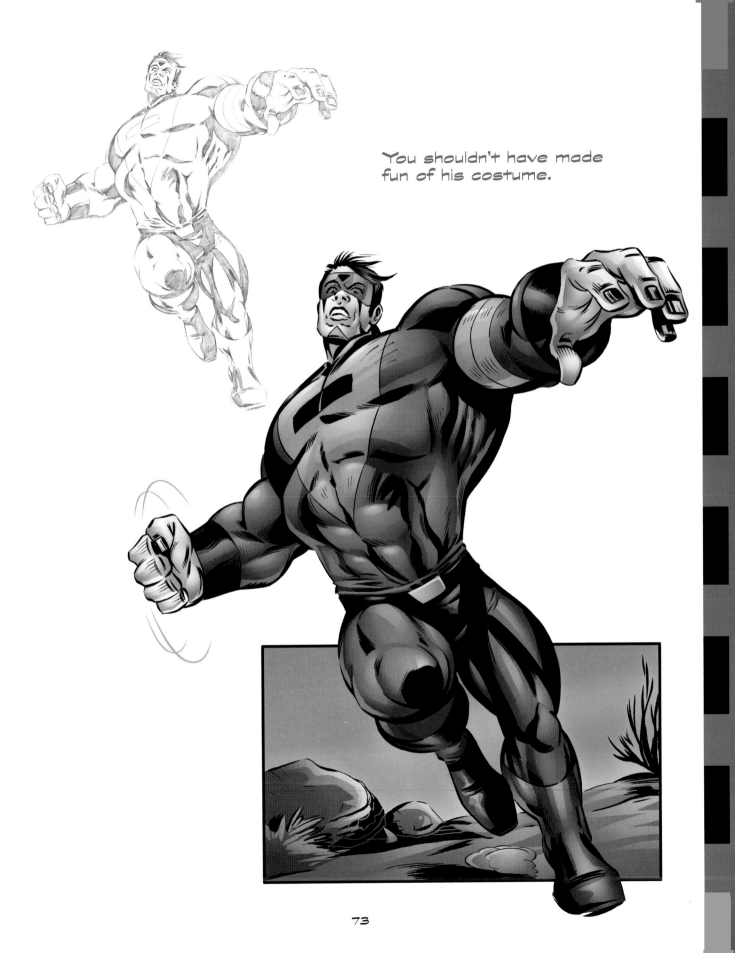

You shouldn't have made fun of his costume.

SUPPORTING CHARACTERS

THERE ARE LOTS OF OTHER IMPORTANT COMIC CHARACTERS who round out the superhero's world. These supporting characters are normal people (imagine that!) living, working, loving, and earning a living in the big, bad city. They are the potential victims of the supervillains and the people our hero must rescue—even if some of them rub him the wrong way.

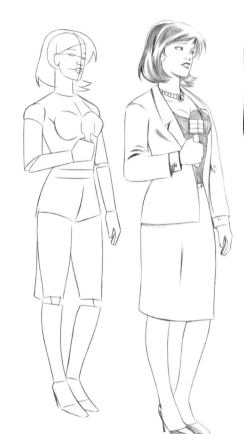

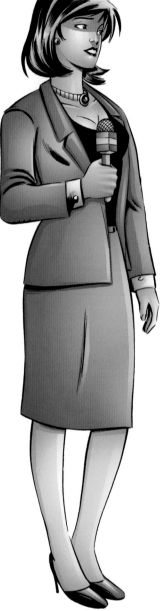

FEMALE REPORTER

She's all business and she doesn't idolize the superhero. She's only interested in getting a good story out of him. You don't believe that? Neither does anyone else—she often becomes the hero's love interest. For her props, give her a microphone, a clipboard, or an attaché case.

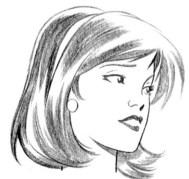

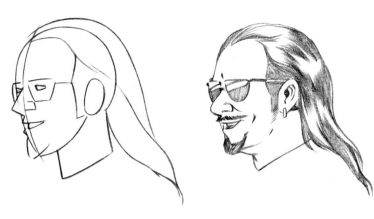

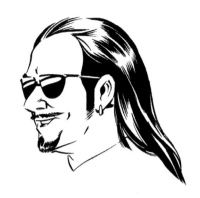

PAPARAZZO

You need a character everybody hates—someone to be a thorn in the side of the superhero. A paparazzo goes nowhere without his photographic equipment. This poses a danger to the superhero, who must guard his identity from the prying paparazzi eyes—and ubiquitous camera lenses. Draw this character in casual clothing, with lots of bags filled with gear, and the worlds worst haircut.

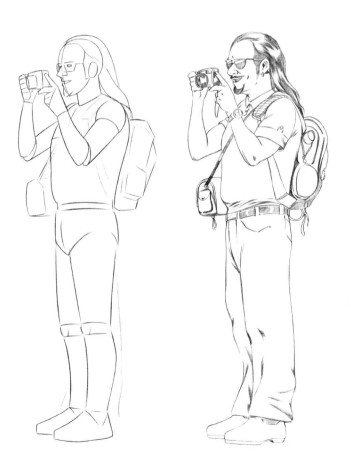

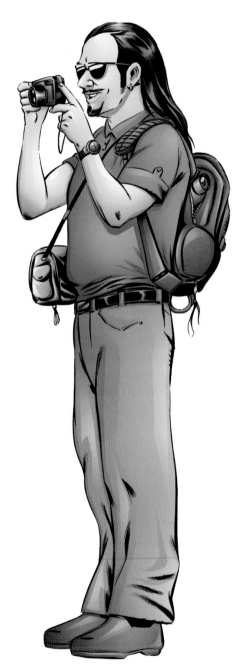

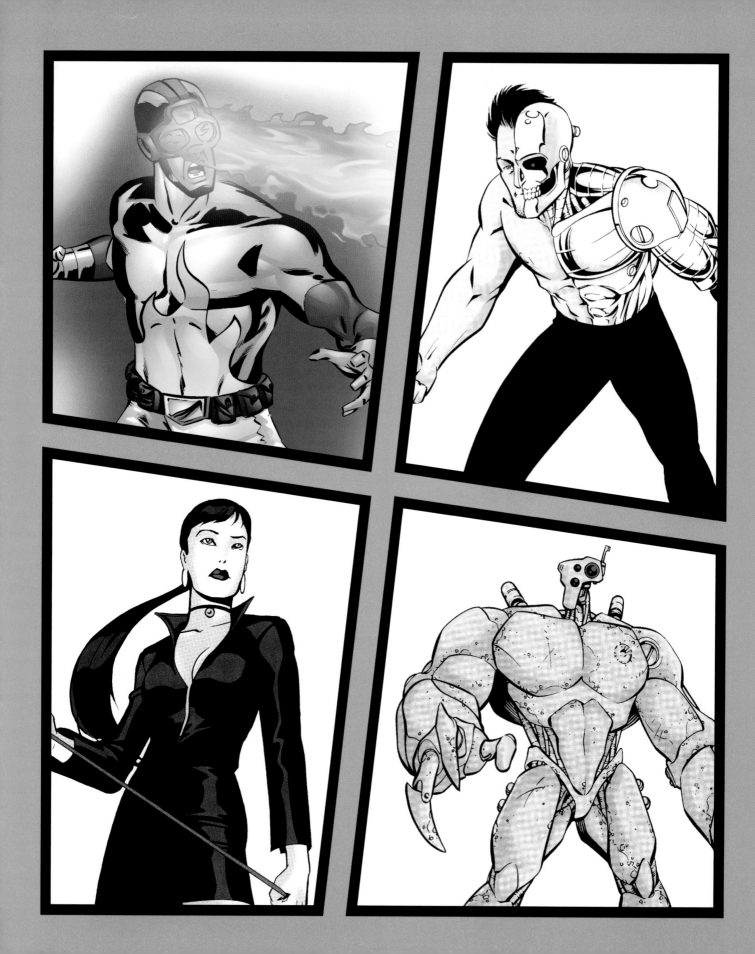

EVIL, AND LOVING IT

YOU'VE HEARD THAT IN EVERYONE THERE'S A LITTLE GOOD, DEEP DOWN INSIDE. Not with these guys. You can't drill that far. Some bad guys have superpowers from being exposed to radiation, toxic waste, or other environmental factors. In other instances, they've built contraptions to give them special abilities. Bad guys and gals can come in all shapes and sizes, but the one thing they have in common is that they make a splashy appearance and cast a dark luster whenever they enter a scene.

DEATH RAY

THE CHARACTER WHO POSSESSES A DEATH RAY is a particularly dangerous and painful opponent for the hero. Death rays can emanate from many places on the character, including the eyes, the visor, the top of a helmet, the fingertips, the palms, the chest (if there's a special mecha attachment or a large crystal there), or a ring on the finger.

 Death rays are dramatic because they kill s-l-o-w-l-y. They weaken the good guy by sapping his life force. You can only fight off a death ray for so long before you begin to succumb. It's sort of like sitting through an insurance sales pitch.

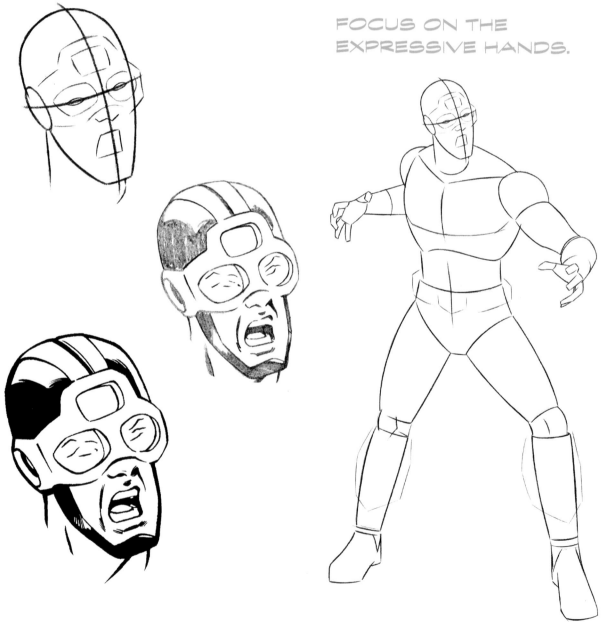

FOCUS ON THE EXPRESSIVE HANDS.

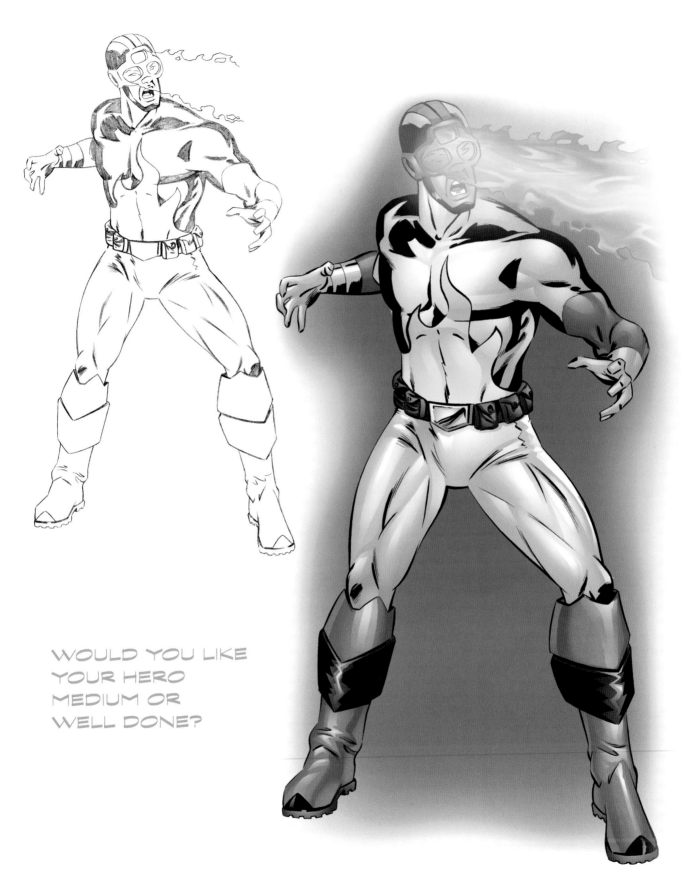

WOULD YOU LIKE
YOUR HERO
MEDIUM OR
WELL DONE?

NATURAL-BORN KILLER

TALK ABOUT KILLER GOOD LOOKS. She's got 'em. When considering this kind of character, however, look past the obvious style, and remember that she still needs a solid foundation, like the one in the construction step here. She's got classic, attractive proportions.

Her hair is jet black, long, and straight. The lips are blackened. This is a severe look, and severe is good for villains. In comics, long gloves are usually reserved for the wicked. So is a slit dress.

RELAX THE POSE SO THAT HER STANCE DOESN'T APPEAR STIFF.

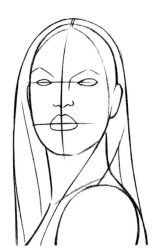

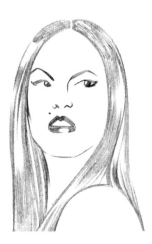

HOLDING A GRUDGE IS
BAD. HOLDING A GRUDGE
WHILE HOLDING A LASER
RIFLE—REALLY BAD.

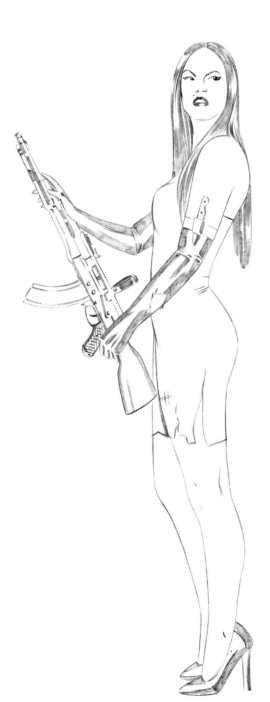

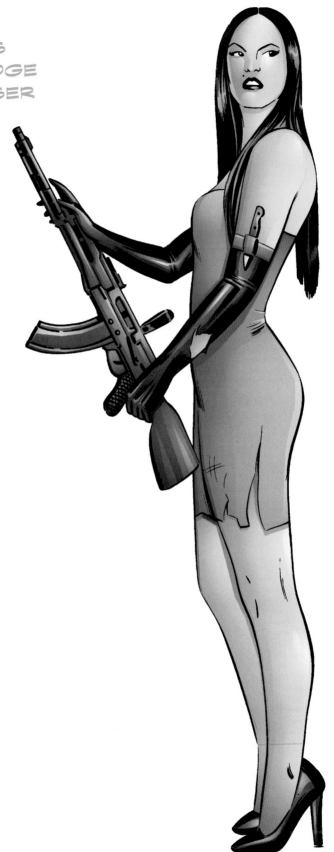

GIANT CLAMP

THERE'S A LONG HISTORY IN COMICS OF CHARACTERS using mechanical devices to enhance their strength. This character is doubly dangerous because he's also a giant. Our superhero, small and helpless, is trapped in his viselike grip.

With the "surround helmet" and backpack, this mecha unit is a life-support system, which means it's vulnerable; there has to be a way of disabling it. But there's very little time before our hero gets pancaked. He can't get out, so what's he gonna do?

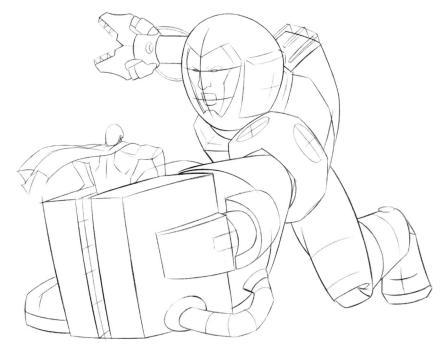

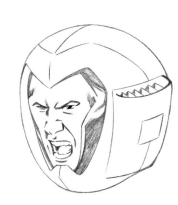

ENLARGE THE CLAMP, AND MAKE IT LOOK THICK.

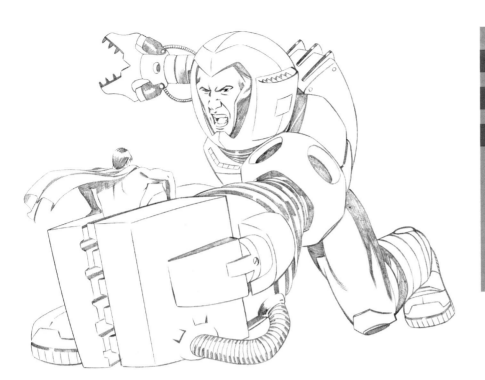

PROPORTION TIP
Note how huge the near clamp hand is compared to the far clamp hand. This difference in size, combined with the use of foreshortening in the near arm, makes the figure appear three-dimensional.

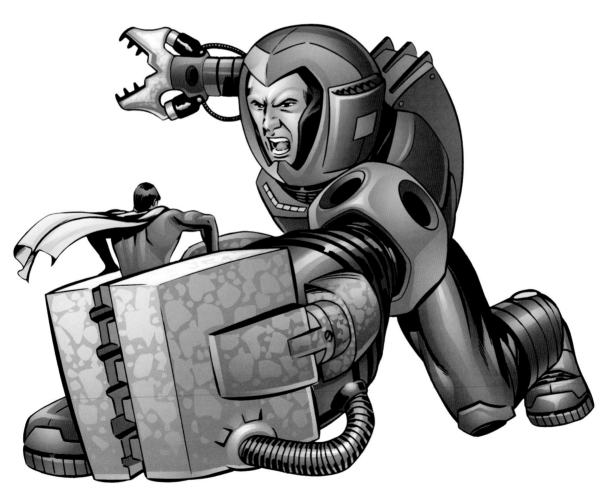

VAMPIRESS

THE UNDERWORLD IS FILLED with darkly charismatic characters. Among the most popular is the vampire, especially the female undead. She's both dangerous and seductive. She's a black widow, luring you with her drop-dead good looks and then taking her bite. This type of character often promises to be good and leave her evil ways behind her. And I believe her.

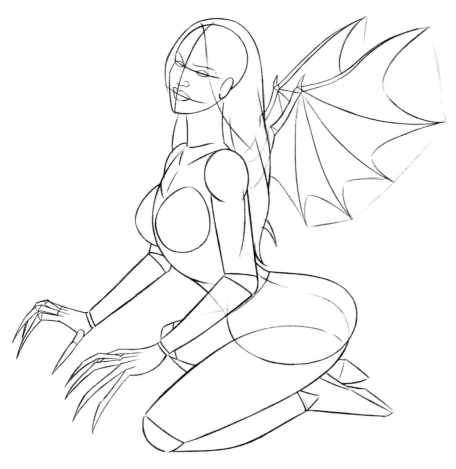

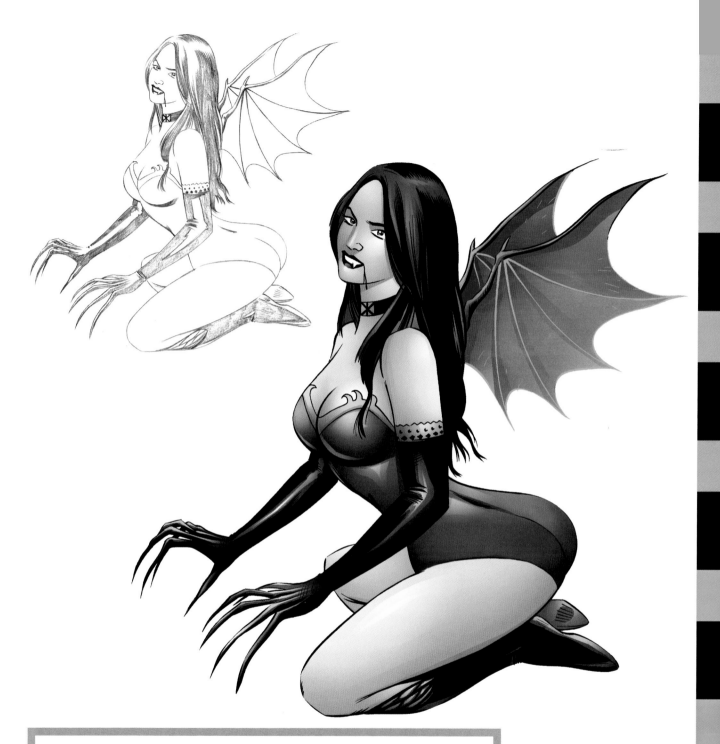

VAMPIRE WINGS AND MORE

In addition to wings, you can give your vampire girl a neck choker, amulet, long gloves, skull motif, a staff, blackened fingernails, blackened lips and rings with occult symbols on them. The wings can be small and decorative, as seen here, all the way up to massive and all-enveloping.

ARMED AND DANGEROUS

THIS IS WHAT HAPPENS TO AN ACCOUNTANT AFTER HE GETS MUGGED. Vengeance is a great motivation in comics—and in life in general. Like the wimp who gets sand kicked in his face, the former victim of crime transforms himself into the ultimate criminal!

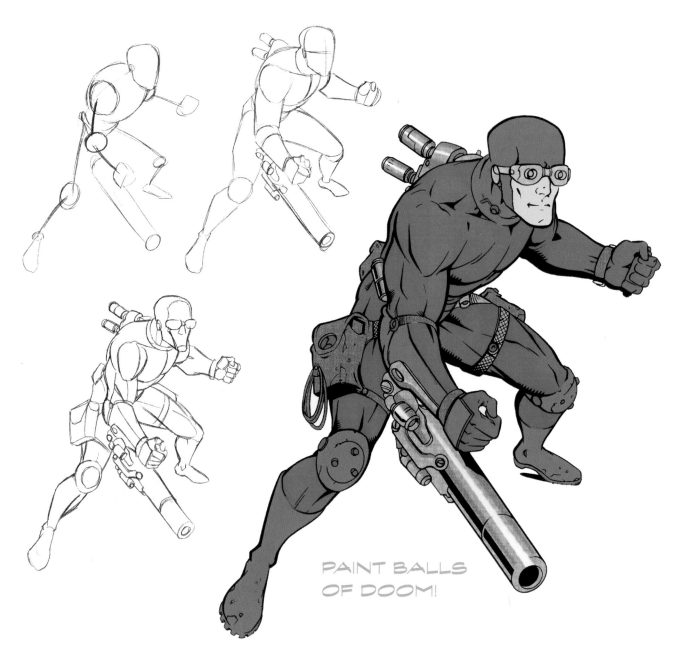

PAINT BALLS OF DOOM!

VAPOR

ONE STRONG VACUUM CLEANER and it's all over for this guy. Creatures made out of gaseous material are in a constant state of flux—like streams of smoke perpetually drifting apart and coming together in random patterns. They hover above things in an ominous, evil manner and appear or disappear at will, like a fog bank that can suddenly drift in and out of nowhere.

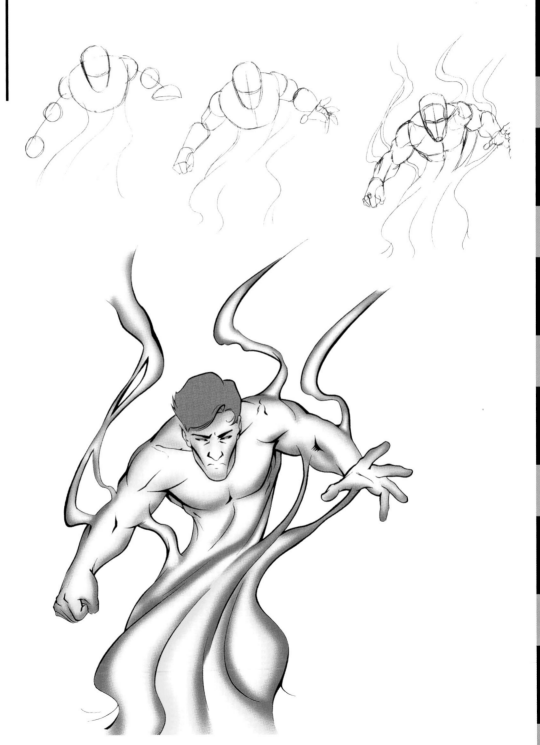

A GIRL AND HER KOMODO DRAGON

SOME PEOPLE GET A COLLIE. Bad gals get more creative with their pets. Good thing she has a leash—in many cities, it's illegal for you to walk your poisonous lizard without one. Difficulties aside, however, you can teach it to fetch a lot of things: the newspaper, slippers, a person.

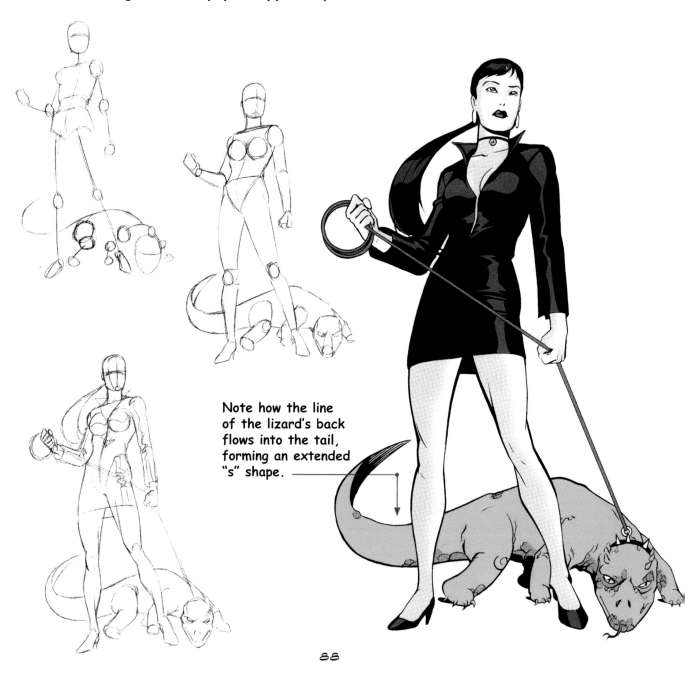

Note how the line of the lizard's back flows into the tail, forming an extended "s" shape.

BAD TO THE BONE

WE ALL KNOW THAT THE BAD GALS of comic books are physically strong. But it's also important to be aware of what makes them appear that way. One important element is the shape of the shoulders. Notice how square they are here; there's no drooping at all. The stance is also one of confidence.

Her slippers are reminiscent of Kung Fu martial arts shoes, and it'd be no surprise if she also had a world-class spinning back kick. And note the long dragon tattoo, which runs the entire length of her right leg. This means that whatever evil gang she's with, she's in it for life.

CYBORG

QUESTION: WHAT DO YOU GET WHEN YOU RIP the outer coating off of a cyborg? Answer: A really ugly cyborg. They are creatures that are half-organic/half-machine. They have skin and hair, but underneath is pure microprocessor. The hydraulics need to have just enough detail to look convincing.

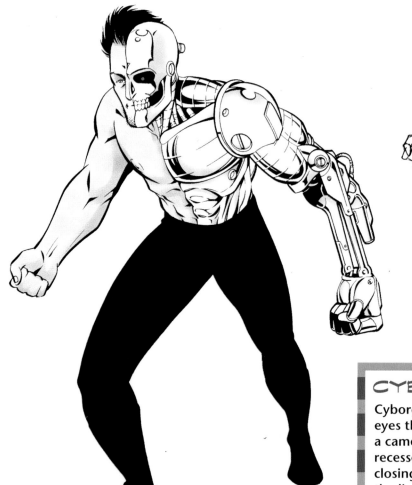

CYBORG EYES

Cyborgs can have mechanical eyes that open and shut like a camera shutter. They are recessed opening up and closing down, depending on the light and how far it is trying to see.

KILLING MACHINE

HERE WE HAVE A MASTER KILLING MACHINE. The head is small because he doesn't have to do much thinking. It has only one task—to destroy. Look at what gets the emphasis: those massive claws. It can crush anything it gets its claws on. Its weakness is that it lacks agility and cunning.

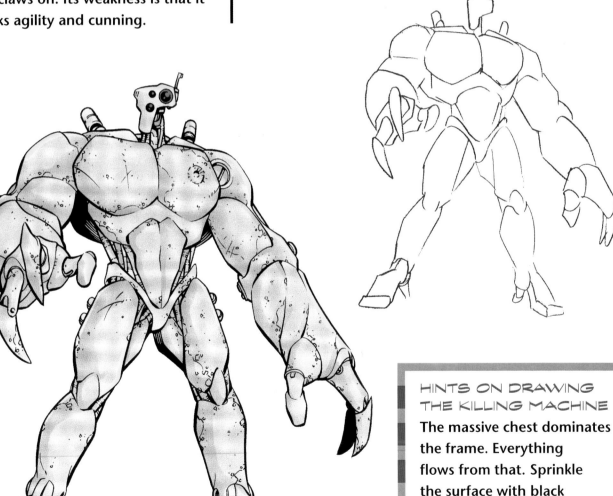

HINTS ON DRAWING THE KILLING MACHINE
The massive chest dominates the frame. Everything flows from that. Sprinkle the surface with black specs, which gives it the appearance of rock.

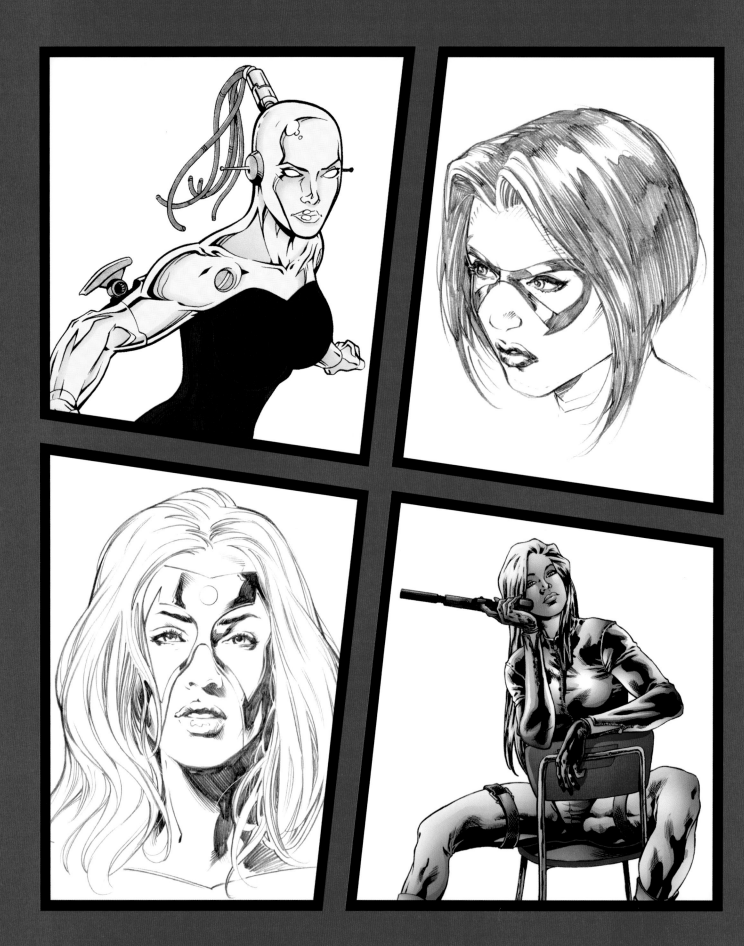

CHAPTER 6

DRAWING FIERCE FEMALES

FEMALE HEROES AND VILLAINS HAVE AN EDGE over their male counterparts: They're beautiful. This is sometimes distracting to enemies, which can prove to be their downfall. In this chapter, we'll combine the elements of character design, figure drawing, and costume to create dynamic characters.

NOT JUST ANOTHER PRETTY FACE

LET'S START WITH THE ESSENTIALS OF THE TYPICAL FEMALE HERO. The eyelids hang heavily on the pupils. The lips are oversized. The jaw should be strong but not too angular. The nose is only partially defined on female characters; barely articulate the outline of the nostrils, and leave off the bridge of the nose. Female facemasks range from practical to extravagant, fashionable accessories. And for a finishing touch, draw hair that breezily surrounds her face and gently falls down to her collarbone.

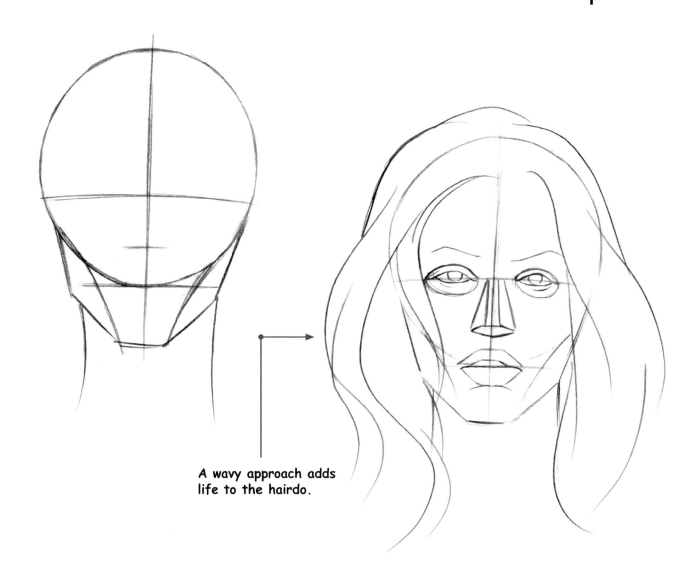

A wavy approach adds life to the hairdo.

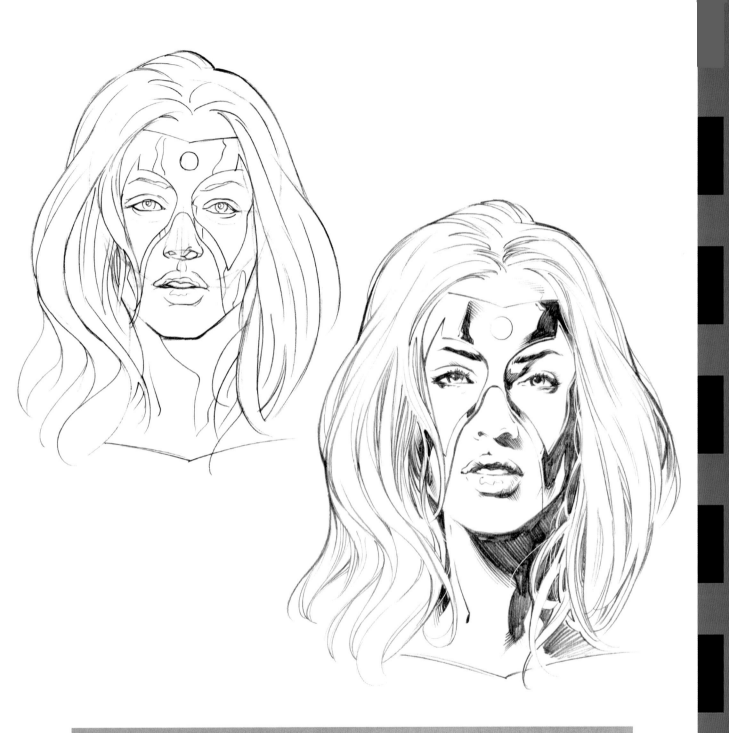

FACEMASKS

How do those facemasks stay perfectly in place throughout a fight scene
with no strap holding them in place? That's one of the liberties you can take
as an artist. Because the eyes are so important on beautiful action heroines,
the openings on women's facemasks are often huge, unlike those for men.
This ensures that the eyes are seen clearly by the reader.

FIERCE FROM ANY ANGLE: PROFILE AND ¾ VIEWS

LET'S LOOK AT SOME IMPORTANT TECHNIQUES to keep in mind when drawing heads at these angles.

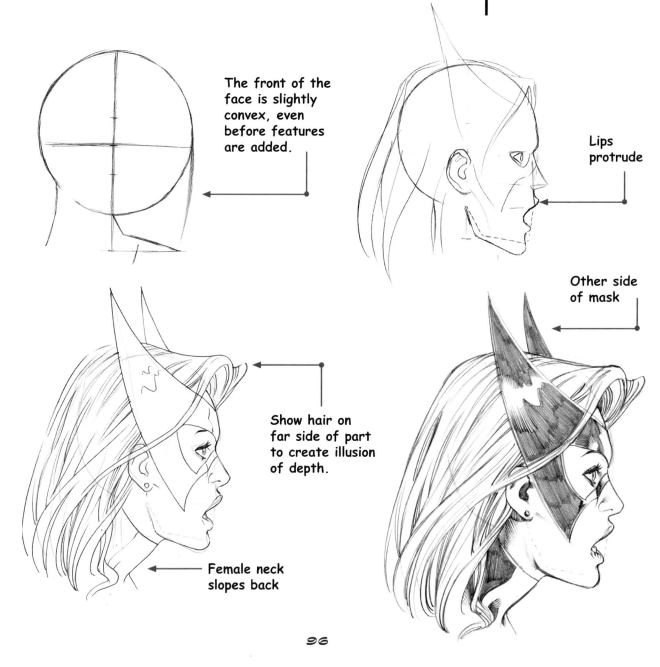

The front of the face is slightly convex, even before features are added.

Lips protrude

Other side of mask

Show hair on far side of part to create illusion of depth.

Female neck slopes back

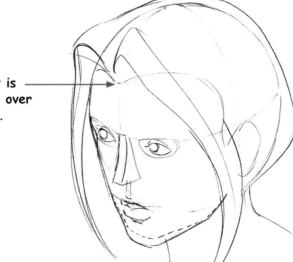

Small chin size

Not all comic book gals have long hair. This hairstyle is called a bob. It's short, with a part in the middle, and wraps around the face. Make the hair longest in front, and chop off the portion on the back of the head.

The part is centered over the nose.

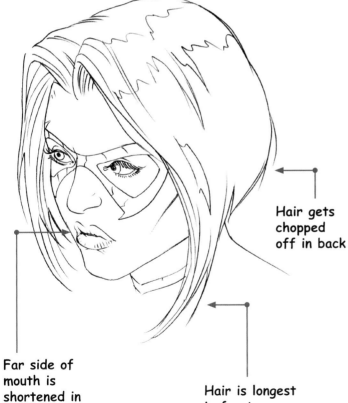

Far side of mouth is shortened in ¾ view

Hair gets chopped off in back

Hair is longest in front

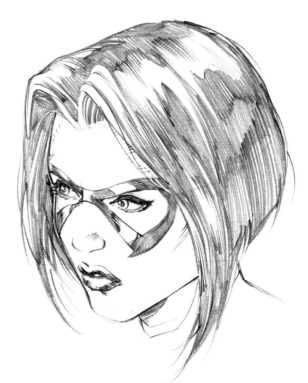

97

THE PLANES OF THE BODY

WHEN LIGHT SHINES DOWN ON A FIGURE, it will cast shadows on the face and body. The location of the light source provides the direction for the shadows. This effect adds a dramatic feeling to your work and also makes your characters seem more realistic and three-dimensional.

THE PLANES OF THE BODY IN REFLECTIVE COSTUMES

Light falls from above onto the top half of the figure but leaves the bottom half in shadow.

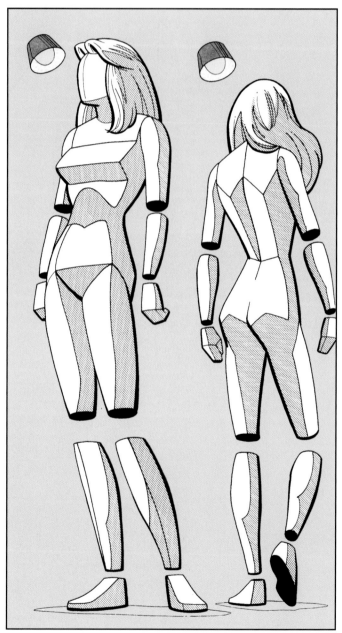

KNOCKOUT POSES

AFTER LEARNING TO DRAW THE FIGURE, the next step is learning to draw the figure in dramatic, eye-catching poses. First and foremost, a good pose shows a flexible figure. It also strikes a decisive position. Compare the dynamic and static poses in these three figure pairs.

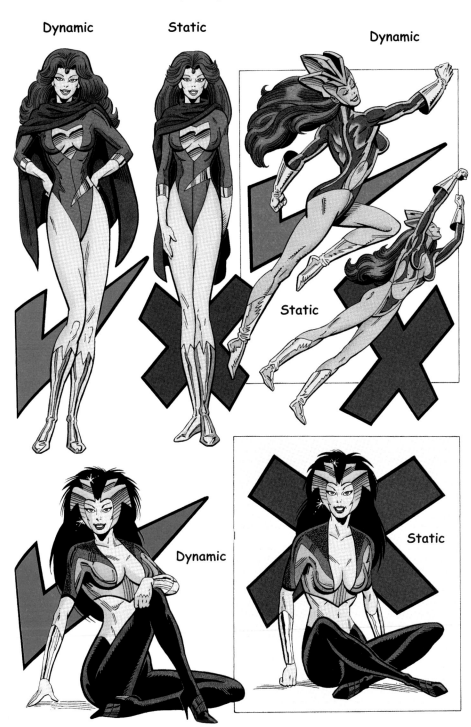

Dynamic

Static

Dynamic

Static

Dynamic

Static

THE BODYGUARD

THIS CHARACTER IS A STAPLE IN TODAY'S COMICS. To her, taking out a bad guy is just a job.

She wears a shiny black "skin suit" and boots. Note the highlights that are created on the outfit by leaving areas light instead of black. She can work for a good guy or use her skills to protect a bad guy.

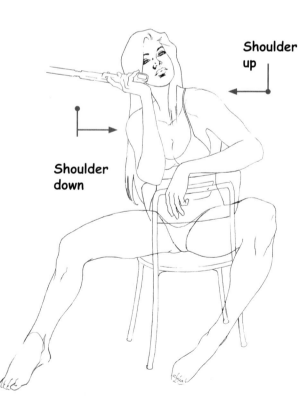

Head tilts back, revealing long neck

Hips widen as they travel downward

Hand bends over chair back

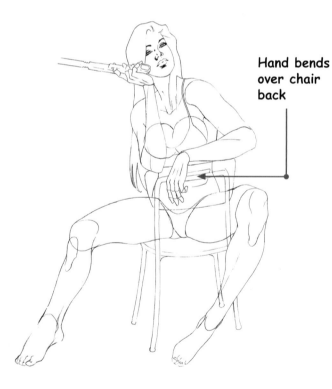

Shoulder up

Shoulder down

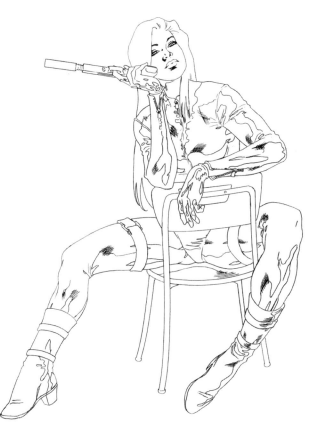

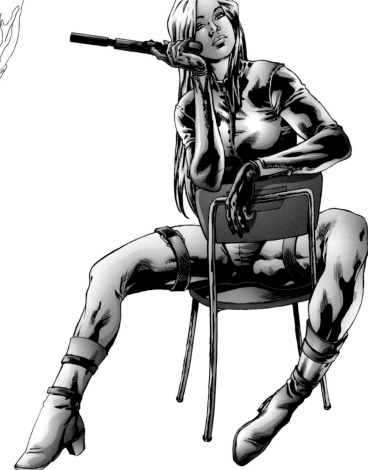

THE ORDER OF THINGS

Some artists like to draw the chair first, lock it in place, and then draw the body to conform to it. They feel it gives the character a greater look of solidity when things are drawn in that order. Others, however, prefer to draw the body first to get the pose exactly the way they want it. They add the chair later, making it conform to the body. Use the method most comfortable for you.

THE PROFESSIONAL

IF SOMEONE NEEDS TO BE RESCUED, she's always up for it. One look at her posture tells you that she's the best in the business. She uses two handguns. Always two. It's more dramatic visually to see two bursts of gunfire coming from a single character. She doesn't care who she rescues, as long as it pays.

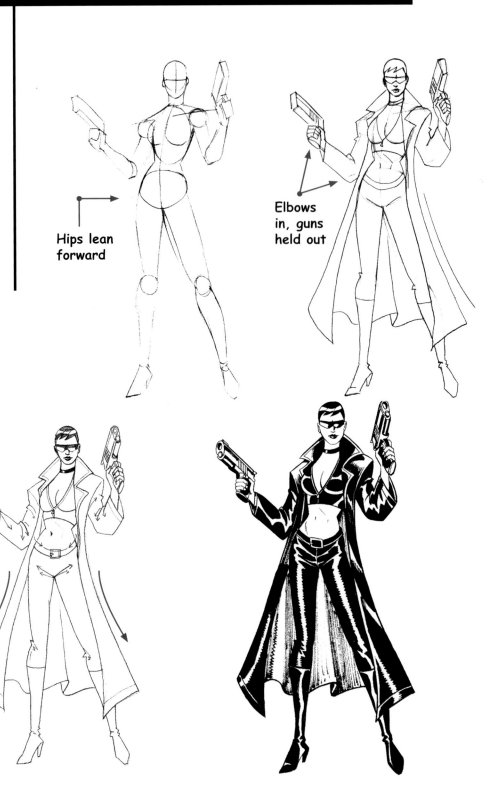

Hips lean forward

Elbows in, guns held out

Coat fans out at the bottom

ANDROIDS

ANDROIDS ARE MECHANIZED HUMANS, so they need some gadgets here and there to remind readers that they're robots. However, don't overdo it. Androids are effective because they look almost human. The surface must look shiny—all androids come with a spit shine.

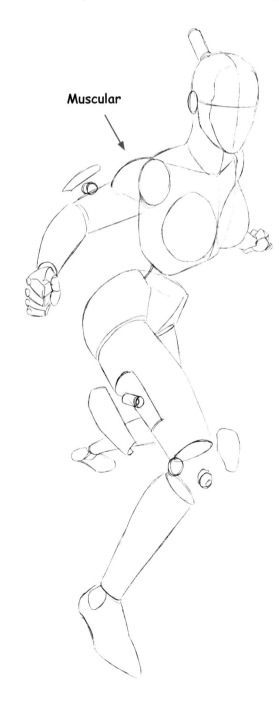

Muscular

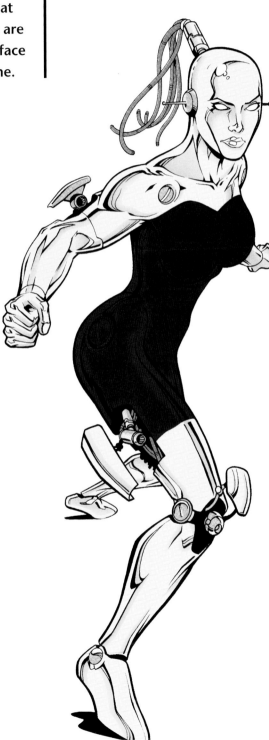

SUPERPOWERS

WHEN YOU THINK OF SUPERPOWERS, you probably think of super strength or maybe flying ability. That's old stuff! Here are the latest, cutting-edge powers your comic book superheroines and supervillains must have in order to survive in an action hero-eat-action hero world.

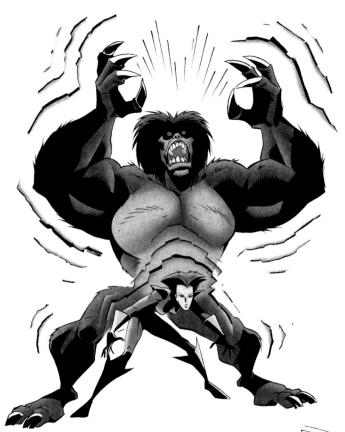

SHAPE-SHIFTING

Provoked to respond with great force, this character summons all her energy and changes form into an awesome monster. Note the motion lines around the character, which indicate a process in action.

ATOMIC PUNCH

This goes way past ordinary super strength; it's a power so great that each blow splits atoms, creating a small nuclear explosion.

SUPER SPIKES

The spikes grow out of her body and shoot at anyone who tries to get in her way. Great power, but tough on dresses and skirts.

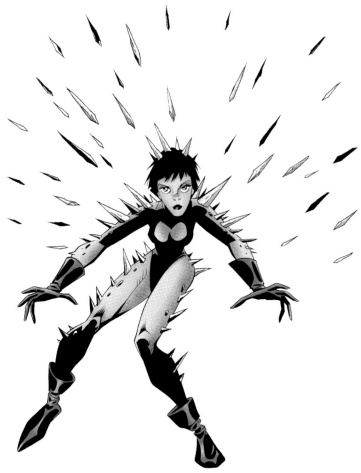

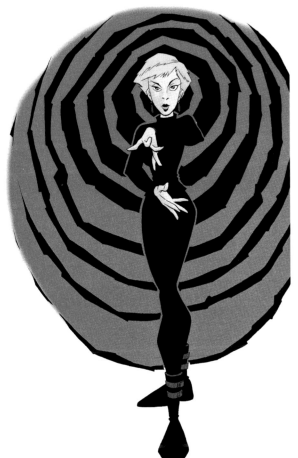

HYPNOTISM

Don't stare at her eyes! Too late. You're frozen. See how easy that was? To indicate that mesmerizing power, draw diabolical hand gestures, a deadpan stare, and a background of swirling, concentric circles.

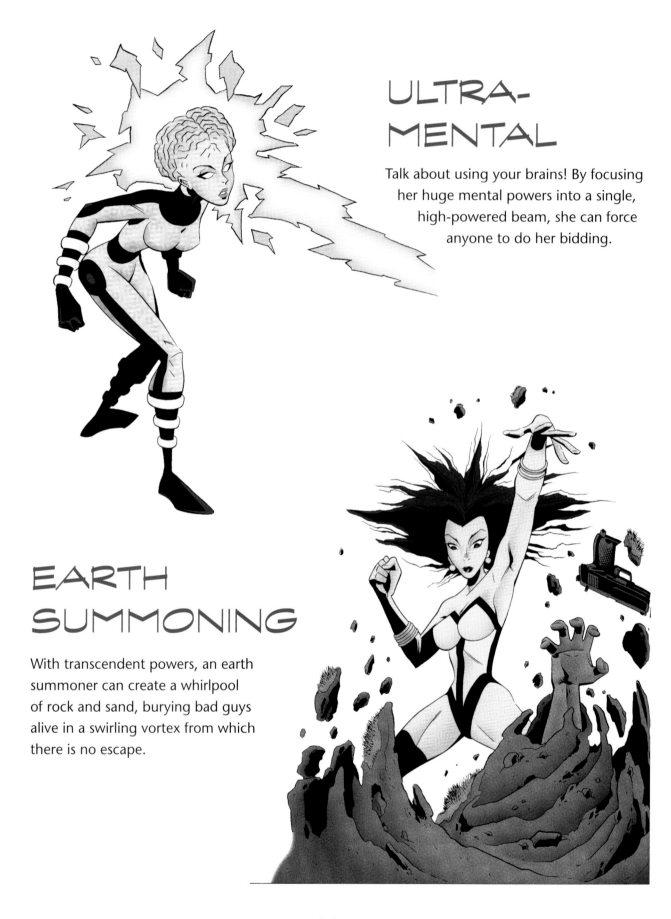

ULTRA-MENTAL

Talk about using your brains! By focusing her huge mental powers into a single, high-powered beam, she can force anyone to do her bidding.

EARTH SUMMONING

With transcendent powers, an earth summoner can create a whirlpool of rock and sand, burying bad guys alive in a swirling vortex from which there is no escape.

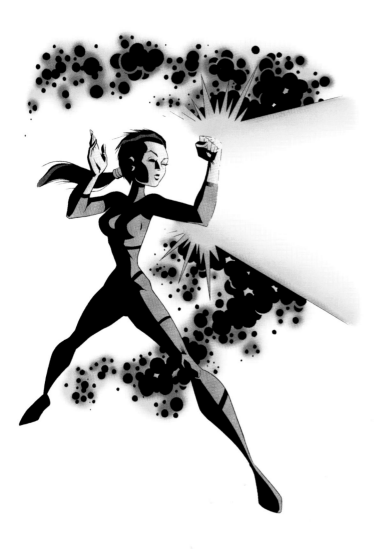

BEAM BLASTING

Power beams always come in handy. The area surrounding the power beam should be filled with a darker pattern to emphasize and contrast with the beam.

PYRO-TERROR

This character sprays powerful, hot flame. She's better than any ordinary flamethrowers because she never runs out of juice.

COMIC BOOK LIGHTING

COMIC BOOK LIGHTING IS MORE DRAMATIC than that seen in real life. To achieve this stylized look, we use shadows. Shadow is used in comics for several reasons. First, it creates more intensity. Second, it makes objects look real and three-dimensional. And third, it creates dramatic contrast. Let's see how to add this effective accent to your drawings.

LIGHT AND SHADOW

SHADOWS VARY IN PLACEMENT depending on the position of the light source. If you throw light at an object from the left, you'll get a shadow on the right side of the object. Shine some light on the top of an object and a shadow will form below it.

No Light Source

The candle is not yet illuminated, so the figure exhibits no shadows and has limited impact.

Light Source Directly Overhead

Ovehead light casts shadows downward onto the face and neck. This creates a hard look.

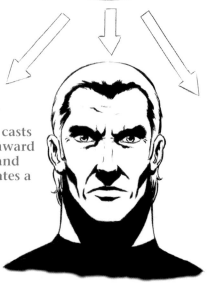

Light Source from the Left

Light hits the character diagonally, throwing shadows over almost all of the right part of the face and neck. It's an excellent, moody look.

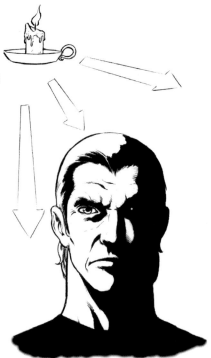

Light Source from the Right

Place the light source to the right, and shadows form to the left.

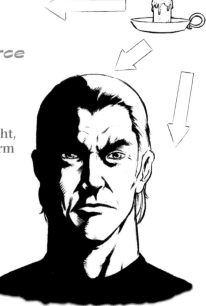

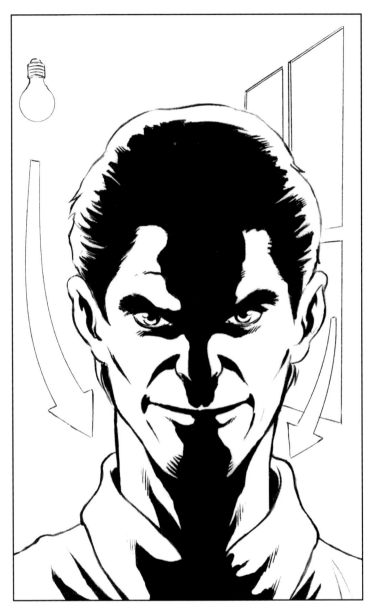

Opposing Light Sources

Having light sources on both sides of the head or figure is a cool look, pooling up black shadows vertically down the middle of the face. It's often seen at intense moments.

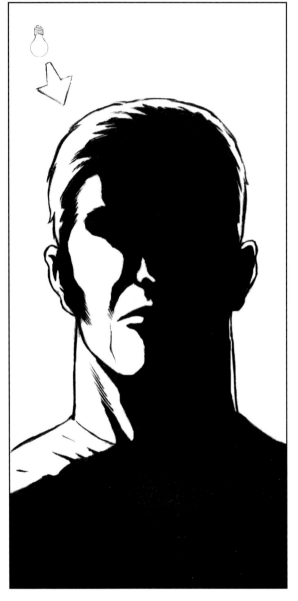

Faint Lighting

Low-voltage light appears in environments such as dark warehouses, prison cells, and creepy castles. The effect it yields is called *edge lighting*, because the rim of the darkened figure is illuminated.

LOW-LIGHTING A CHARACTER

OUR STARSHIP COMMANDER is looking at his ship's control panels and doesn't like what he sees: enemy vessels coming right at him. For a tense moment like this, "underlighting" (light that comes from below) is a good choice. It increases the intensity. The lights from the control panels can serve as the light source. Remember, any feature that protrudes from the face will cast a shadow, such as the nose, chin, and cheekbones.

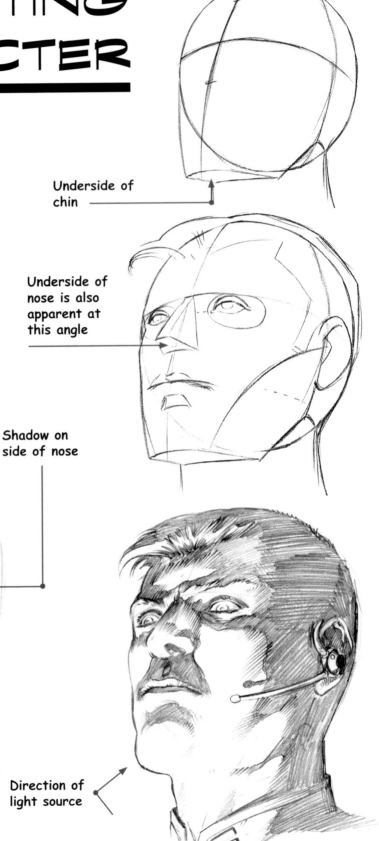

Underside of chin

Underside of nose is also apparent at this angle

Slight protrusion for cheekbone

Shadow on side of nose

Direction of light source

TOP-LIGHTING A CHARACTER

LIGHT THAT SHINES DOWN FROM ABOVE AND CASTS HARSH SHADOWS creates the appearance of deep pockets under the eyes. It gives characters an intense look that's perfect for barbarians. The bottom of the face disappears into the spreading shadows, melding with the neck and hair. Keep in mind, though, that even if a portion of your finished line work will end up obscured by shadow, you'll have the most success if you sketch the entire face to start—yep, even the part that eventually gets blanketed with darkness.

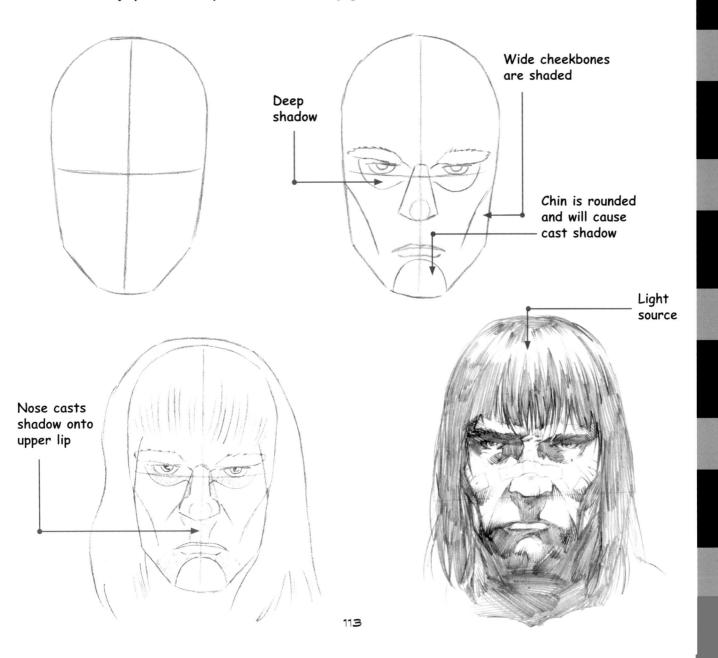

Wide cheekbones are shaded

Deep shadow

Chin is rounded and will cause cast shadow

Light source

Nose casts shadow onto upper lip

LONG SHADOWS FOR MOOD AND POWER

FOR YOUR CHARACTER TO BE IMPRESSIVE, he needs to cast an impressive shadow. Here are examples showing a comparison of how much more effective long shadows are than small ones. The long ones create a sense of tension, of impending danger, of loneliness and quiet about to be disrupted by violence.

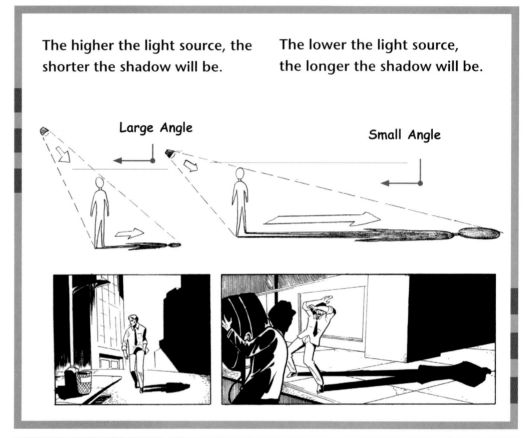

The higher the light source, the shorter the shadow will be.

The lower the light source, the longer the shadow will be.

Large Angle

Small Angle

A WORD ABOUT THE LIGHT SOURCE...

The front of the man's torso is in shadow. It follows, then, that the sun must be behind him. That leaves no choice: His shadow's gotta fall in front of him.

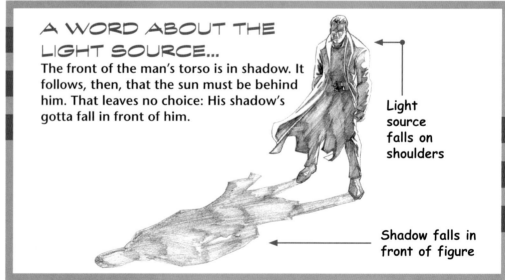

Light source falls on shoulders

Shadow falls in front of figure

CREATING CONTRAST

HERE'S A SECRET THAT'S USED ALL THE TIME by top comic book artists: Use lots of black in designing a scene to create contrast. This can be in the form of shadows, silhouettes, or partial silhouettes. To make the objects pop off the page, position them against white spaces.

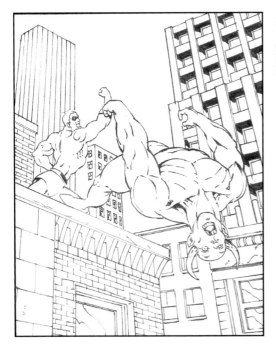

Simple Line Art (White on White)

Although this is a good drawing, it's missing impact. That's because there are basically no black areas in the picture.

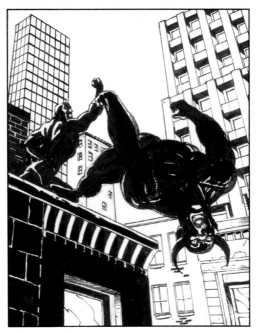

Silhouetted Foreground

Here, the two figures and the near building are silhouetted against the background.

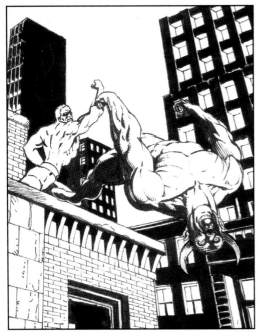

Silhouetted Background

Now it's the buildings in the background that are in blackened silhouette. Adding white areas for windows helps define the architectural elements.

MORE EFFECTS

ALL OF THESE EFFECTS GREATLY ENHANCE THE MOOD AND ATMOSPHERE of a scene. Let's check out how they're created, and, even more important, how you can create them.

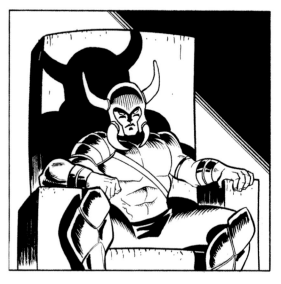

Light From Below

Light shining up from below a figure creates enlarged shadows plus spooky effects. It's an ominous, powerful look.

Silhouetted Figures

Shift the emphasis by putting the man completely in silhouette, which enhances the sense of menace.

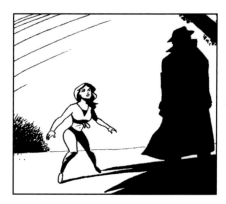

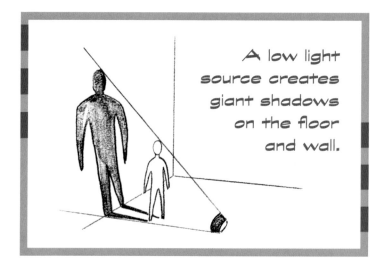

A low light source creates giant shadows on the floor and wall.

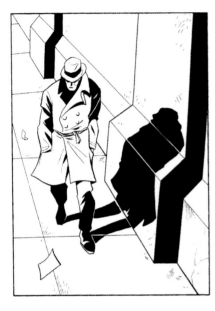

Shadow Cast on Irregular Shape

The shadow assumes the irregular planes and angles of the wall.

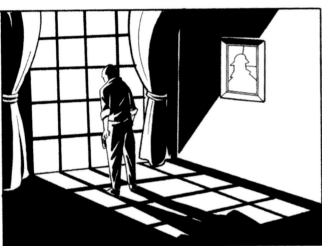

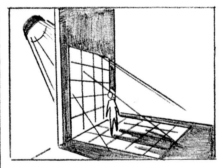

Pattern Shadows

Venetian blinds, shutters, windowpanes— they all make good patterns for shadows.

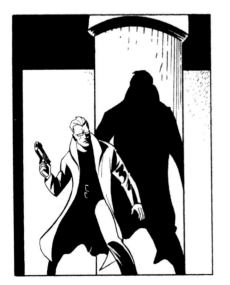

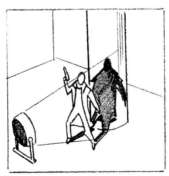

Wrap-Around Shadows

The column isn't large enough to contain the entire shadow, so the shadow appears to bend around the column, giving the illusion that the column is round.

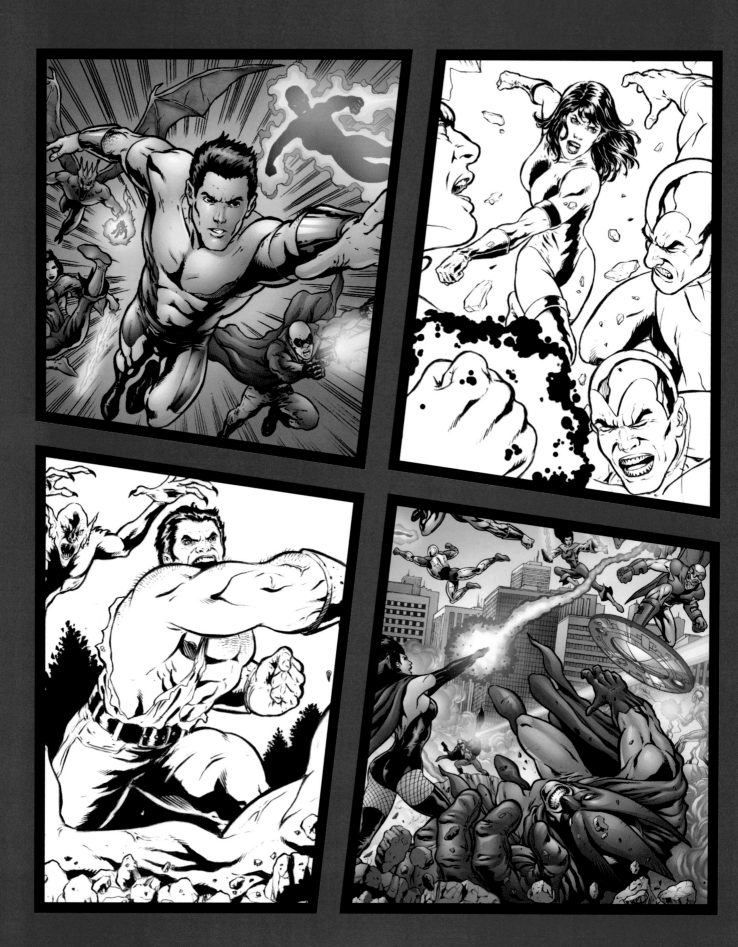

COMIC BOOK ELEMENTS

SPEECH BALLOONS, CHARACTER PLACEMENT, EFFECTIVE PANEL SEQUENCING, AND COOL LOCATIONS—the skilled artist must use them all. Capturing, directing, and focusing the reader's eye is the great quest of every comic book artist who attempts to draw a splashy, full-page scene or a striking cover. We'll break down the sequential storytelling process so that you can begin to lay out your scenes into panels with speech balloons.

THE SPLASH PAGE

THE SPLASH PAGE IS A SCENE THAT TAKES UP NOT JUST A PANEL BUT THE ENTIRE PAGE, so it needs to be eye catching. Drawing the splash page takes a little planning. The page is a large canvas; your job is to direct the eye to the important elements of the scene. To do this, you need to create a *circle of focus*. If, when looking at a picture, the eye gets stuck on something or the characters don't lead the eye from one to the other, then the picture won't hold the reader's attention. By placing the main elements of the action on a continuous loop, you keep the eye from traveling out of the scene.

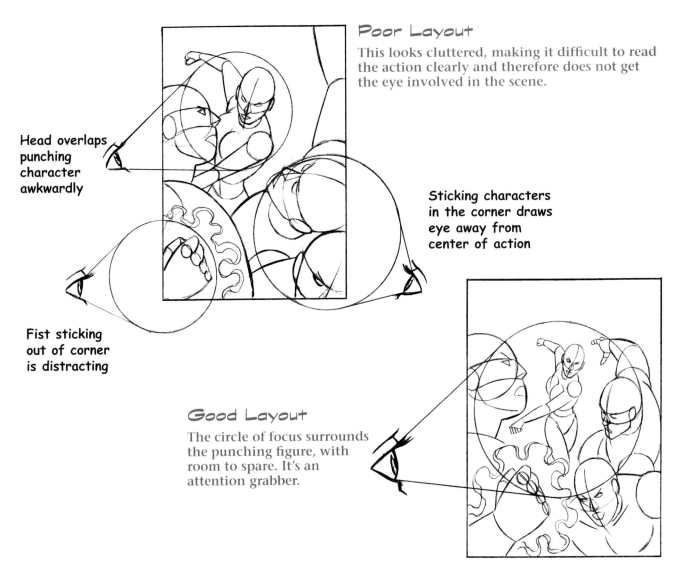

Poor Layout
This looks cluttered, making it difficult to read the action clearly and therefore does not get the eye involved in the scene.

Head overlaps punching character awkwardly

Sticking characters in the corner draws eye away from center of action

Fist sticking out of corner is distracting

Good Layout
The circle of focus surrounds the punching figure, with room to spare. It's an attention grabber.

Continuous Flow Established

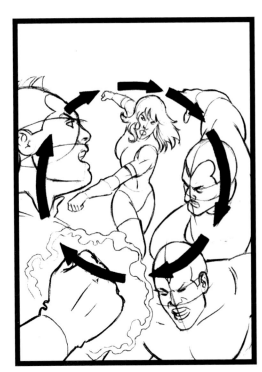

In the cleaned-up version, the circle of focus becomes even clearer: A circular path through the layout creates one continuous loop, keeping the eye from wandering off the page.

Final Layout

Putting it all together, we can feel the punch. We also experience the impact on those bad guys. The action is clear and uncluttered. And we get a sense of depth from positioning figures in the foreground and others in the background.

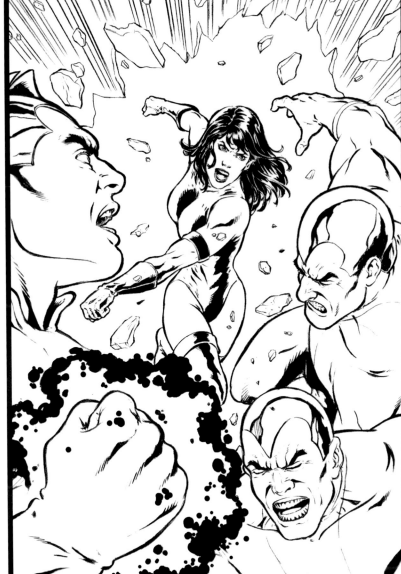

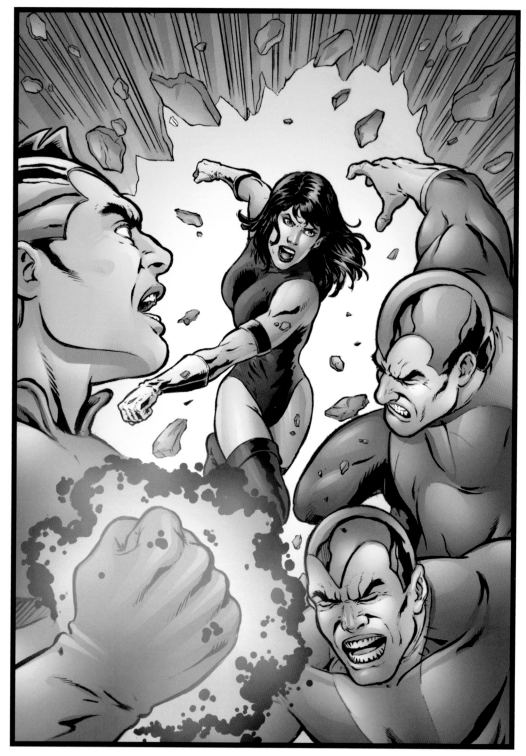

Color Version

Colors are used to create intensity. Red, a strong and eye-catching color, is at the center of the action.

WHAT MAKES AN EFFECTIVE LAYOUT?

The elements that make this layout work will apply to any good splash-page composition. To start, the central punching figure has a good amount of surrounding space so that the action doesn't appear cramped. This is very important. And by staggering the figures—one in the foreground, one in the middle ground, and one in the background—you create a sense of depth.

Additionally, there's a clear sequence of action: As one mutant is dispatched with a punch, another is about to jump in to attack. Take that, you pointy-eared slimeballs!

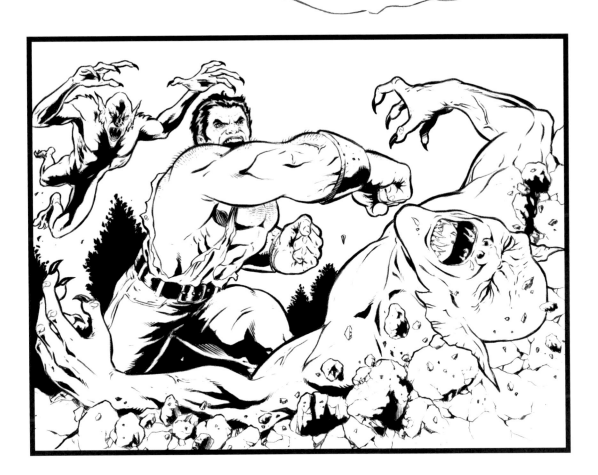

USING THUMBNAIL SKETCHES

Small, diagram-type sketches in which the characters are drawn roughly just for placement are called *thumbnails*. They're invaluable for laying out a scene, because they're so simple that you don't feel married to any particular drawing. If one isn't working, try another. Don't fall in love with the first one you draw. Try several variations. You can then choose the best from each and combine them into one effective splash page.

Wrong

The action is cluttered. It's messy looking.

Wrong

Everyone in this thumbnail is too far from the reader. Nothing is up close to create that in-your-face perspective for which comics are famous.

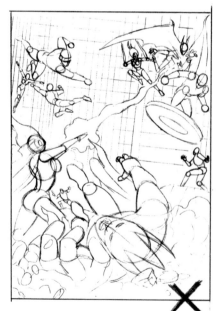

Better

The bad guys are now the biggest character in the picture. But the group of superheroes is cluttered together.

Right

This is the one. Did you notice how the eye goes from one character to the next in a circular path? The heroine and that burst of energy are the center of focus. Plus, she's got more room around her than any other character, because she's the star of the page.

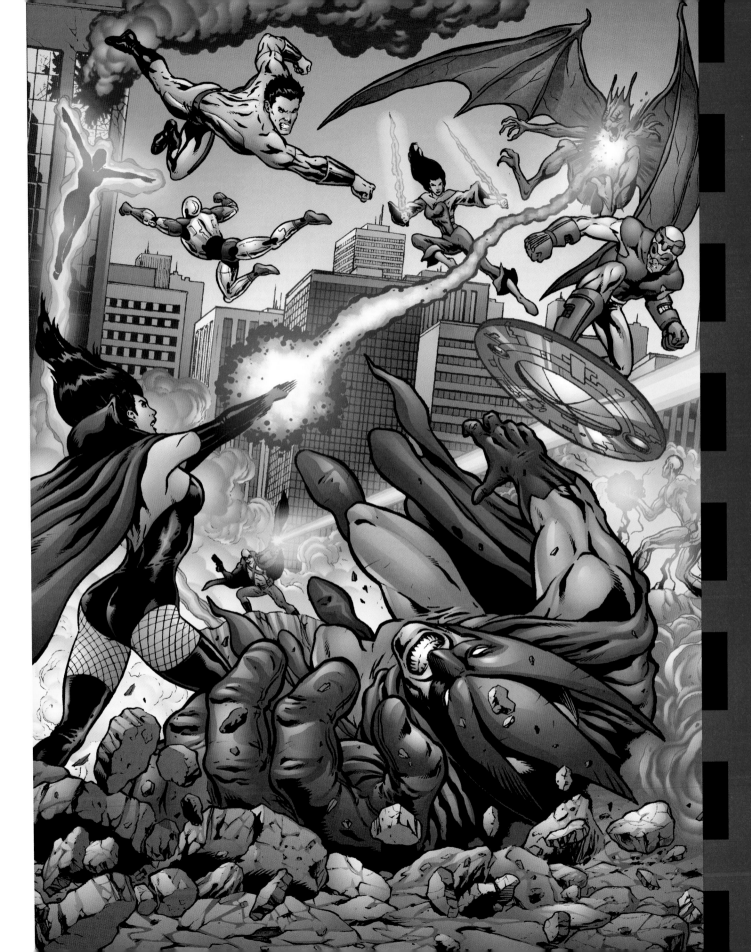

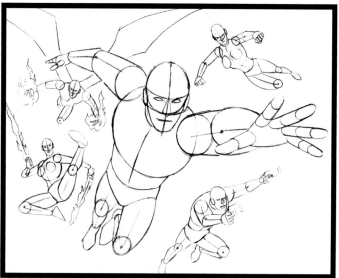

TEAM SPLASH PAGES

The splash page is also an important tool for establishing the superhero team. When flying together as a group almost in formation, they appear more dramatic. Note the pleasing effect of the circular layout, which is just as important in team splash pages as it is in "non-team" splash pages.

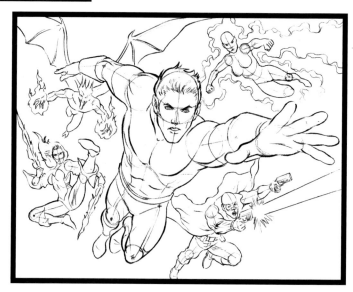

EACH CHARACTER STRIKES HIS OR HER
SIGNATURE POSE.

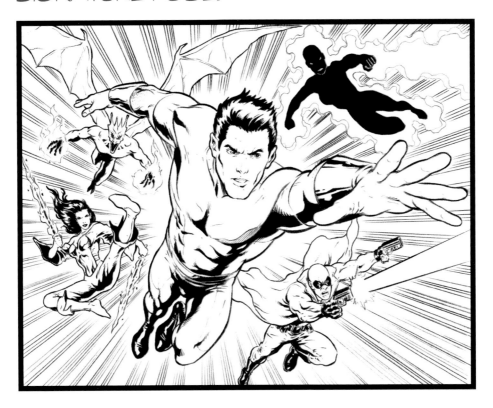

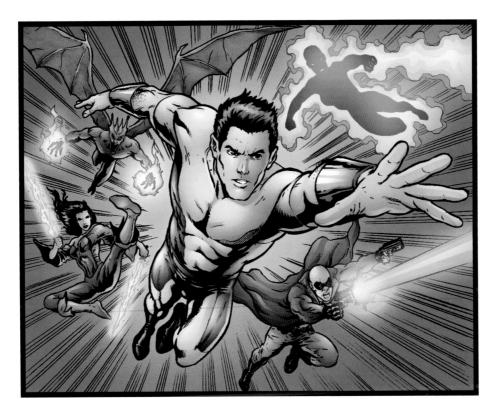

SUPERVILLAIN TEAM SPLASH PAGE

Supervillains generally have more extravagant costumes than superheroes, if that's even possible. They're also shown smiling—as they anticipate the mayhem they're about to unleash on hapless citizens. Like superhero teams, villain teams have a cast with different talents. The layout concepts are also the same: All supporting characters fall on the periphery, orbiting the leader and creating an effective circle of focus. Note the forced perspective of the leader's pointing hand, which mirrors the outstretched hand of the superhero leader on page 127.

JUST ANOTHER QUIET AFTERNOON IN THE CITY.

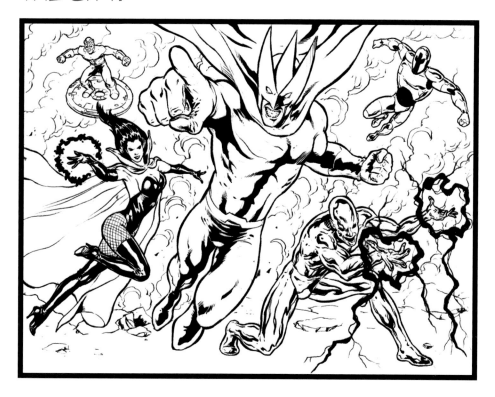

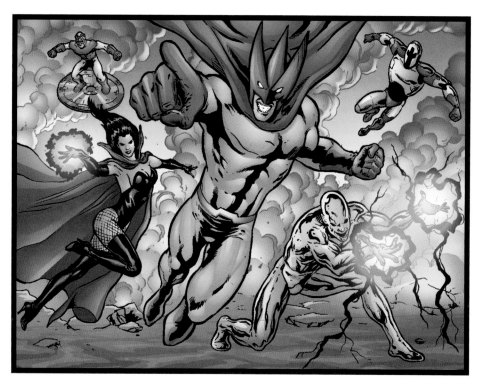

SPEECH BALLOONS AND CAPTIONS

SPEECH BALLOONS ARE FIRST READ left to right and then top to bottom. The primary direction is always left to right. Poorly placed speech balloons cause consternation. The reader has to reread the balloons in a different order to make sense of it, and that slows down the flow of the story. The last thing you want to do is frustrate your reader with speech balloons that are laid out confusingly.

Captions are the rectangular boxes set with quick snippets of information to cue the reader into the scene (like box 1, right).

Incorrect Placement

Oh boy, look at this. After all of that hard work drawing a perfectly good scene, don't ruin it by obliterating it with caption boxes and speech balloons covering the characters.

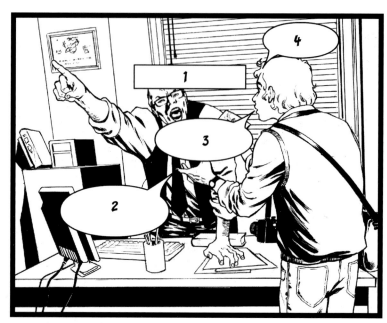

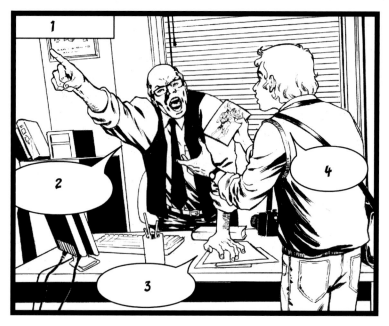

Correct Placement

Counterclockwise placement of caption boxes and speech balloons is effective, provided that these elements still read from left to right and that they leave the image uncluttered.

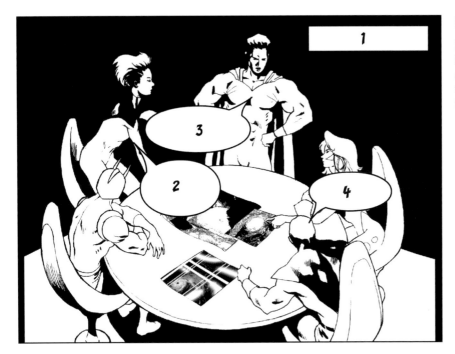

Incorrect Placement

Here, the speech balloons invade the center of the scene and steal the focus away from the characters. In addition, their order is all mixed up.

Correct Placement

The two characters at the top of the page are engaged in a dialogue and therefore must speak sequentially; that's why balloon 3 must follow balloon 2.

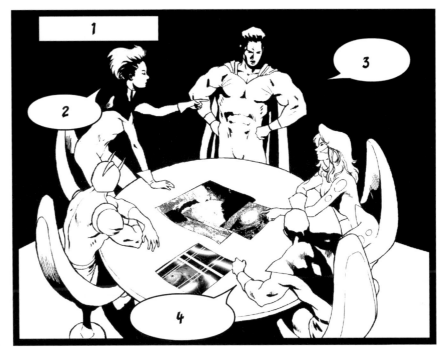

PANEL SEQUENCING

THE VISUAL FLOW OF A STORY IS THE MOST IMPORTANT ASPECT OF LAYING OUT A PAGE OF SEQUENTIAL PANELS. To do this, we have to begin to vary the types of "shots" in a panel. Too often, beginners do too much in full shots, so their comic book pages are filled with characters drawn from head to foot, with no close-ups or medium shots. Also, you should begin to include other angles instead of relying exclusively on front angles. Let's see how using a variety of angles creates a sense of energy and dynamism in a scene.

Beginner Approach (right)

Some shots are varied. The characters are good. What's wrong? The main event (the hold up) is repeated in two panels, and there are no close-ups or medium shots to jar the reader. This is a sleepy page.

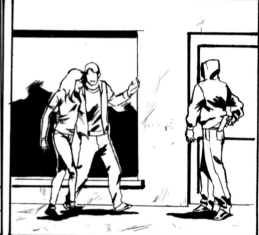

Pro Color Approach (opposite)

The first shot is neutral to set up the story and give the reader information fast and simple. Danger starts to happen in the second and third panels, which is why the angle has been *tilted*. Then we go in tight for a couple of quick close-ups of the dangerous guy in panels 4 and 5. In panel 6, the shot widens out for the climactic moment when the superhero enters the picture.

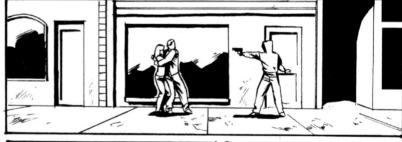
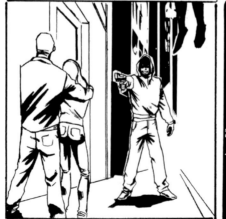
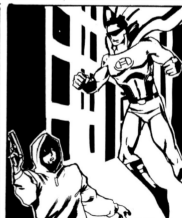

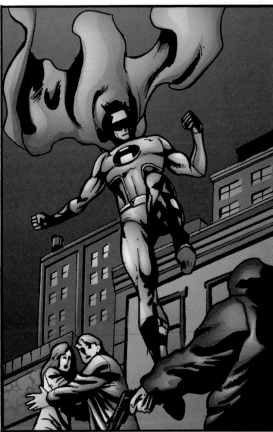

Beginner Approach

Here's the setup: Some Navy SEALs are furtively approaching a submarine in the water. They sneak under the hull, attach a bomb, and swim off. What's wrong? Every shot is at a distance, which is uninvolving. Plus the angles are too mild for such a dramatic and dangerous operation. Where's the close-up of the device? This page is missing the key ingredient.

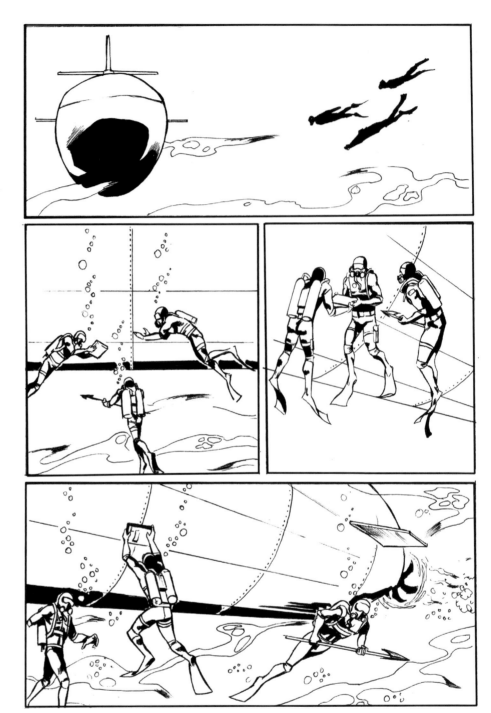

134

Pro Approach

The scene starts off with the men swimming up to the sub. This immediately makes things more dramatic than the first version, in which the SEALs were swimming horizontally to the sub directly in front of them. The second panel is a tried-and-true classic: It's a reverse angle, meaning you're looking at one person's shoulder. This is always a good visual device. Next, the artist goes in for close-ups of, what else, the bomb! The first version didn't emphasize the most important component of the scene. If we're going to wait in suspense for something to blow up, we had better see the device ticking away.

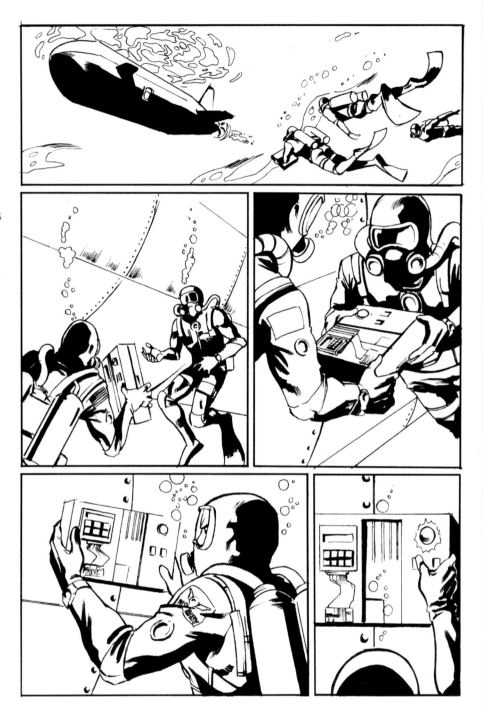

LOCATION, LOCATION, LOCATION

COMIC BOOK LOCATIONS ARE MORE THAN JUST BACKGROUNDS. They're strategically chosen environments that help to flesh out the story. The locales should also be interesting and evocative. For example, say that you have a scene in which a villain is talking to one of his investors about taking over the world. You could draw the scene with the two of them plotting over dinner at a restaurant, or you could stage the scene in the villain's vast warehouse, filled with his personal collection of Ferraris and Lamborghinis. Now *that* says something about the bad guy's wealth and self-indulgence.

Ballroom

Many superheroes are wealthy. Opulent locales provide a great cover for their true identities and a rare glimpse into the lives of the rich and famous. At these events, plotting and scheming goes on behind the scenes between such types as diplomats and captains of industry. Opulent settings also give you a chance to show off your characters in stunning outfits.

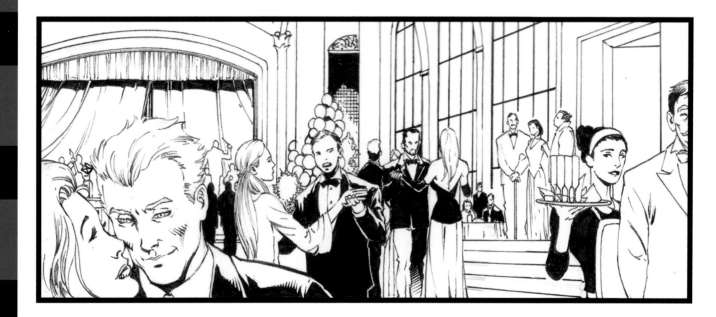

Other locales are more gritty. They, too, speak to the character of the villain. The best locations are specific and register with the reader at a glance. This section will show you some of the classic and ever-popular locations for the notorious criminals of comics.

Prison Visiting Room

The prison visitation center is where the prisoner meets with his lawyer, separated by a bulletproof Plexiglas partition. Bad guys often have "mobbed-up" lawyers. Some of these nefarious inmates direct their gang activity from behind bars. Others get released on a technicality, like the witness died. Then the prisoner is free to take revenge on the person who sent him away—the superhero. Note the "pressure marks" the partition makes on the prisoner's forearm.

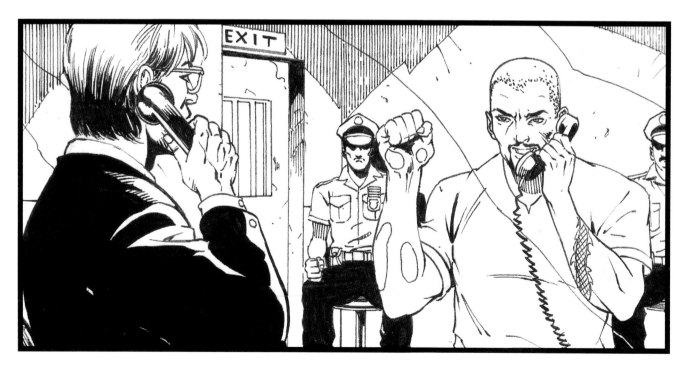

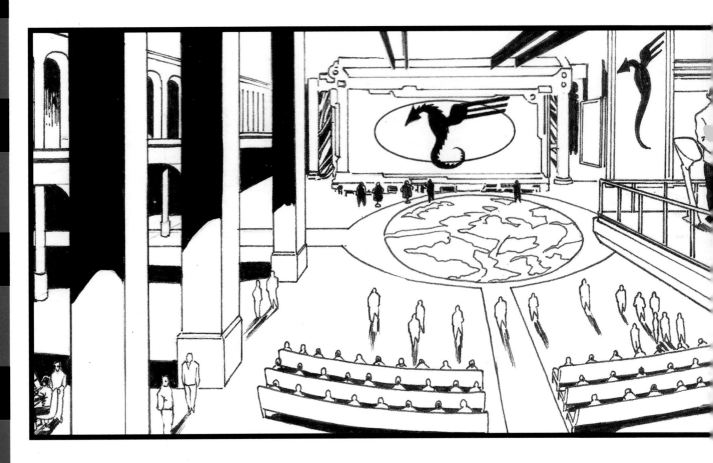

Futuristic

Cool vehicles have always been thought of in terms of the future, ever since Leonardo da Vinci first sketched his concept for a helicopter back in the 1500s. Therefore, to establish a future time, comic books often show new modes of transportation. Here, it's a futuristic subway train system with lots of organic arches instead of the geometric shapes of train stations today. The train itself is in the shape of a monorail. The escalators and partially blackened ceiling convey that this is a subterranean environment.

To create a futuristic look, take an ordinary location, like a subway station, and tweak it by adding some unique architecture.

Headquarters

It's a convention of supervillains: An underground network of powerful criminal masterminds meeting as a great council to divvy up the world's resources. Scenes like this make bad guys part of an elite organization, functioning with one purpose: To get rid of the pesky superhero and, as a result, rule the world. In this setup, the icon for the world appears on the floor, surrounded by a seated council. On the screen before them is the organization's mascot: the dragon. The two-tiered building allows the scene to be viewed from a high vantage point, as though we're looking down at it.

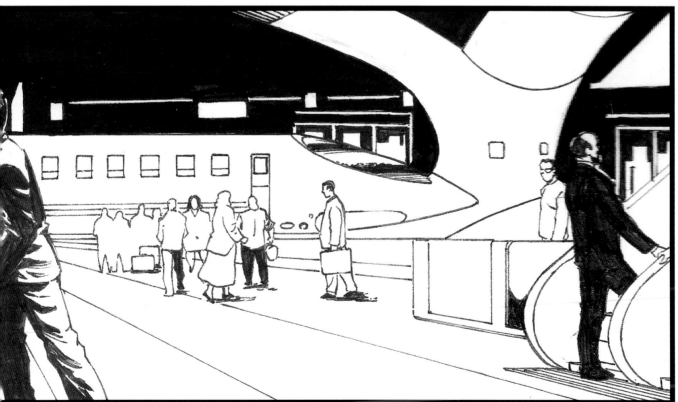

City Hall

Most superheroes live (and work) in a major metropolitan area. And the seriousness of the crimes goes all the way up the chain of command and gets the mayor's attention. City Hall features prosecutors, defense lawyers, judges, criminals, television news reporters, and even the mayor—a host of great characters for crime-fighting adventures. The mayor may make speeches praising, or condemning, the hero on the steps of City Hall. The downtown, city hall setting has to look majestic—it's where justice is served. Note the thick columns and steep steps.

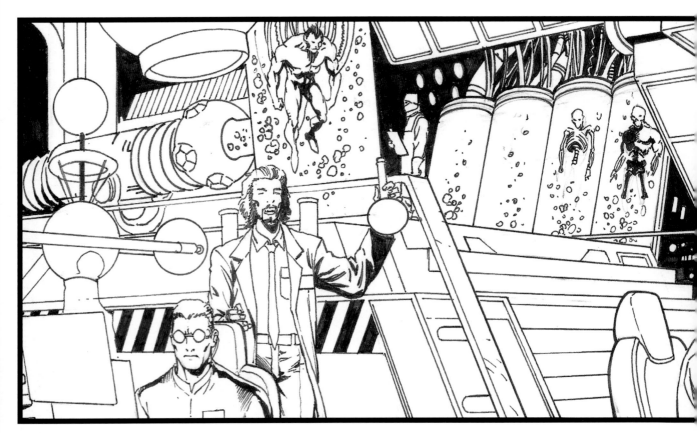

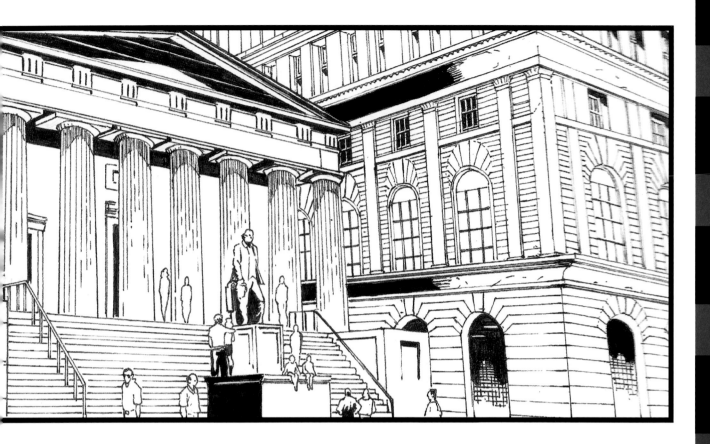

Laboratory

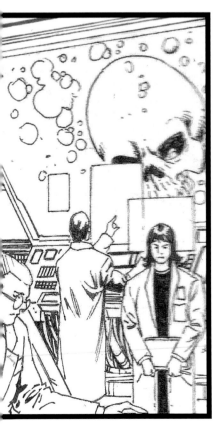

Laboratories are usually vast and crawling with human and extraterrestrial specimens that have been captured. Some alien specimens have tubes attached to them for life-support purposes. Air bubbles are essential for making the cylinders look like they contain liquid. Evil scientists need lots of space for their huge and ultra-powerful experiments. So, everything about the lab is big. And glass is a ubiquitous material in science labs.

INDEX

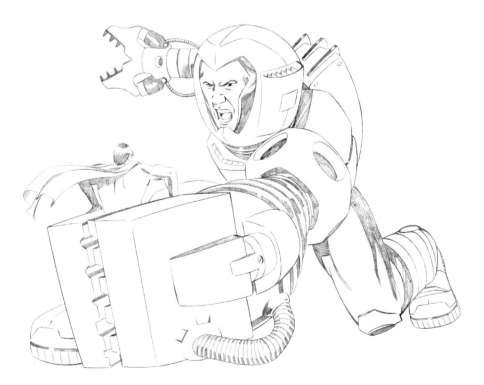

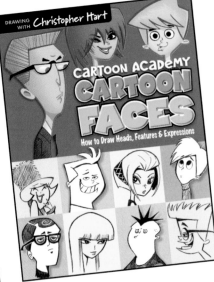
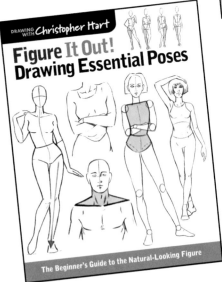
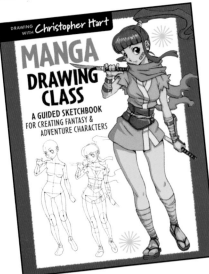